SOTHEBY'S

~ GUIDE TO ~

PHOTOGRAPHS

SOTHEBY'S

∼ GUIDE TO ∼

PHOTOGRAPHS

THOMAS WESTON FELS

Illustrations by James Allen Higgins

An Owl Book
Henry Holt and Company ∼ New York

Henry Holt and Company, Inc.
Publishers since 1866
115 West 18th Street
New York, New York 10011

Henry Holt® is a registered trademark of
Henry Holt and Company, Inc.

Sotheby's Books, a division of Sotheby's, Inc.
New York / London
Director: Ronald Varney
Executive Editor: Signe Warner Watson
Specialist: Denise Bethel, Vice President, Photographs

Library of Congress Cataloging-in-Publication Data
Fels, Thomas Weston.
Sotheby's guide to photographs: an essential compendium of
practical information and recommendations about collecting
photography art from Sotheby's / Thomas Weston Fels.
p. cm.
Includes index.
ISBN 0-8050-4855-3 (hb : alk. paper)
1. Photographs—Collectors and collecting. I. Title.
TR6.5.F45 1998
770'.75—dc21 98-23689

Henry Holt books are available for
special promotions and premiums.
For details contact: Director, Special Markets.

First Edition 1998

Designed by Kelly Soong

Printed in the United States of America
All first editions are printed on acid-free paper. ∞
1 3 5 7 9 10 8 6 4 2

~

Contents

Acknowledgments

Many individuals and institutions have assisted in the work for this volume. While it is not possible to thank them all, I wish to express my sincere gratitude both to those listed and those not.

Photography professionals and amateurs alike from all areas of the field have offered support, advice, and assistance during the course of this project. Among them are, on the publishing side, Denise Bethel, Signe Warner Watson, and Ron Varney of Sotheby's, and Ray Roberts at Holt. Curators, dealers, and institutions responsible for the book's illustrations include Pierre Apraxine and Maria Umali, Gilman Paper Company Collection, New York; Peter Bunnell, The Art Museum, Princeton University; Keith Davis, Hallmark Photographic Collection, Kansas City, Missouri; Joe Deal, Washington University, St. Louis; the Harold and Esther Edgerton Foundation and Palm Press, Inc., Concord, Massachusetts; Kathy Erwin of the Coville Photographic Art Collection, Bloomfield Hills, Michigan; Roy Flukinger, Gernsheim Collection, Harry Ransom Humanities Research Center, The University of Texas, Austin; Jeffrey Fraenkel and Frish Brandt, Fraenkel Gallery, San Francisco; Maria Morris Hambourg, Metropolitan Museum of Art, New York; Anne Havinga, Museum of Fine Arts, Boston; Brooks Johnson, The Chrysler Museum of Art, Norfolk, Virginia; Hans Kraus, Hans P. Kraus, Jr., Inc.,

New York; Mack Lee, Lee Gallery, Winchester, Massachusetts; Barbara McCandless, Amon Carter Museum, Fort Worth, Texas; Therese Mulligan, George Eastman House, International Museum of Photography and Film, Rochester, New York; Weston Naef, J. Paul Getty Museum, Los Angeles; Sandra Phillips, San Francisco Museum of Modern Art; Sally Pierce, Boston Athenaeum, Boston, Massachusetts; George R. Rinhart, The Rinhart Collection; Linda Shearer, Williams College Museum of Art, Williamstown, Massachusetts; Robert Sobieszek, Los Angeles County Museum of Art; Anne Tucker, The Museum of Fine Arts, Houston; Jane and Michael Wilson and Violet Hamilton, The Michael Wilson Collection, London and Los Angeles; John Wood, Lake Charles, Louisiana.

To the many others who offered information, consultation, and respite, I offer my genuine thanks, and hope that the work set out here adequately reflects the time and concern which was extended to me.

Note: Throughout the text specialized or key terms related to photography have been italicized to facilitate easier recognition and identification by readers new to the subject.

SOTHEBY'S

GUIDE TO

PHOTOGRAPHS

1

INTRODUCTION:
Why Collect Photographs?

The one hundred and fiftieth anniversary of photography, celebrated in 1989, occasioned a large array of exhibitions and publications. For over a year photography and its history were widely displayed and discussed both in the United States and abroad. The resulting efforts—books, shows, articles, symposia—still serve as a benchmark in the field. In all the excitement, however, one of the most important points in the recent development of photography went often unstated: the new audience for photography that had emerged in the previous decade. For behind the museums mounting exhibitions and publishers releasing sumptuous volumes lay a revival of interest in the medium that still affects us strongly today. Only some dozen years before 1989, photography was a relatively little-known field. Collectors, museums, and specialists comprised a small club indeed. Major exhibitions and publications on photography were a rarity.

Today, in part due to the activities of 1989, but really only marked by them, collectors and aficionados of photography benefit in several ways from recent developments in the field. Increased attention to photography has produced a new and exciting area of collecting and study, with an infrastructure of institutions, experts, and scholarly aids increasingly comparable to those accorded other major media in the arts, such as painting, sculpture, architecture, drawings, and prints. Perhaps equally important, the nature of photography and its relative novelty as a field of interest, ensure that despite its growth, it continues to retain an intimacy among those who follow it. In its infancy as an art form, photography offers opportunities unique among major collectible media.

The history of painting, after all, stretches back before recorded history, and reached a high level of expression in Europe over half a millennium ago, and in other parts of the world long before. Important works in the field of painting, often rare and by nature unique, are sought after by museums and key collectors; frequently they are priced beyond the means of all but the most wealthy individuals. On the other hand, though photography may arguably be the most important and influential visual medium of the past century and a half, works by its inventors and early masters are still available, and at prices many can afford.

The result is an area of collecting in which there are new opportunities for professionals and amateurs alike. As interest in photography increases through books, exhibitions, and reviews, and knowledge of its history grows through the work of curators, scholars, and writers, new artists, bodies of work, and even entire previously unrecognized sectors of the medium come to the attention of collectors and institutions. Each of these new areas, as it reaches the market, offers new potential to shape through collection the future of how photog-

raphy is studied, perceived, and collected by others. Single collections, such as those of Sam Wagstaff and Arnold Crane, collectors whose devotion to the medium played an important role in the development of the new market in photography, have changed the way photography is valued and viewed. The vision of individual institutions and their directors, such as the Canadian Centre for Architecture (CCA) founded by Phyllis Lambert, and the Gilman Paper Company under Howard Gilman, have helped through their particular collecting interests and acuity to shape the field. Their collections have led to exhibitions and books, such as *Photography and Architecture*, from CCA, and *The Waking Dream* from the Gilman Collection, which have been highly popular and well received. These and other new collections have been shown and honored by museums keen to add to the luster of their own holdings, and those who assembled them have been courted as advisors and trustees. The expansion of interest and knowledge in photography has also recently led, for example, to the introduction to the market of daguerreotypes and early photographs on paper, areas previously limited to specialized collections and institutions, thus opening new areas of collecting to others less familiar with these generally more modest but often exquisitely beautiful objects.

The new market in photography developed over a period of twenty-five years. Beginning in Europe in the early 1970s and in New York five years later, photography has progressed from a small field in which there were only a handful of specialized galleries and collections to one in which interest is far more widespread, the pieces of quality sought by collectors more commonly available, and the prices commanded more commensurate with photography's value as art. In contrast to 1975, when one professional remembers only three galleries in the United States devoted exclusively to photography, by the mid-

nineties the annual gathering in New York of photography dealers and galleries was likely to include seventy-five or more major players in the field, and to attract an audience proportionately large. Similarly, among collectors, from a tiny field derived originally from collectors of illustrated books and prints, the number of those interested and actively collecting photography has grown to become an important market in its own right. Values have followed suit. A nude by Paul Outerbridge, sold at auction in 1978 for $1,100, was resold there in 1990 for $33,000; an image of a woman by Tina Modotti, protégée of Edward Weston, sold in 1980 for a little over $1,400, was resold in 1992 for $44,000. While monetary value is only one aspect of a work of art, such statistics clearly indicate substantial development in the collecting of photographs. Despite periodic cycles and changes in the market caused by the entry or exit of key collectors or sources or by movements in the larger economy, both interest and value in photographs have steadily increased from the 1970s to the present day.

The purpose of this book is to introduce potential collectors and others with an interest in photography to the experience of collecting and the rudiments of its practice. Among the attractions of collecting are the knowledge obtained in learning the history of the medium and the satisfaction of recognizing the value and quality of particular works. There is enjoyment in participating in the culture surrounding galleries, auctions, and museums, and great satisfaction in the visual pleasure afforded by the works themselves. For many, these offer a new set of places and priorities, contact with others who share one's interests, and a fresh context for enjoyment and participation. The result can be involvement in programs as a participant, sponsor, or patron, and an expanded relationship with museums, libraries, colleges, and universities through collections, exhibitions, and publications.

Sotheby's Guide to Photographs will first introduce you to the history of photography (Chapter 2), to give an overview of the field. In this chapter you will meet the inventors of the medium, and follow the major chapters of its artistic development. Next, in Chapter 3, some of the particulars of the medium itself will be introduced, offering a technical history that will assist in identifying the various types of pictures likely to be encountered in collecting. Chapter 4 describes various categories of photographs, first by their subject matter and the intent of the photographer, and then according to the view of later curators, scholars, and historians—helpful tools in orienting the collector to the many byways of an unfamiliar field. Chapters 5 and 6 deal with how photographs may be evaluated and then where to find them, essential guidelines to anyone approaching the collecting of photographs in a serious way. In Chapters 7 and 8 we look at how the planning of a collection may be conceived and, once formed, how to look after it. Chapter 9 is a list of resources for further education, research, and advice.

Throughout this book, certain themes will become apparent. Along with knowing the outlines of the field itself, emphasized through references to key artists, periods, and work, two important approaches to collecting are advocated here: starting locally, where your current knowledge will get you further in a new field; and thinking for yourself, making your own determinations of quality and value in order to create a collection that reflects your own interests and taste. It is believed that these themes will stand a beginning collector in good stead; they are of equal use, if already familiar, to more experienced collectors as well.

I hope the *Guide to Photographs* will be exactly that. It is meant to be read and used. Its various chapters offer the basic steps in a process of knowledge and connoisseurship that will

continue and expand during your lifetime as a collector. Photography can be a tremendously exciting field; investigate it, get involved, and enjoy it!

As you begin, there will certainly be questions, which arise with any new endeavor. Don't be afraid to ask them; many do, and such questions are really the only way to new knowledge. The *Guide to Photographs* will answer many of them, but as a quick introduction, here are three heard frequently by professionals in the field:

Why Is a Photograph Valuable?

For most people, photographs are associated with family scrapbooks, snapshots, portraits for business or identification, and a wide range of reproductions, from newspapers and magazines to billboards and posters. Since cameras are readily available, anyone, it would seem, can take a photograph. It takes a visit to a museum, library, or gallery, an experience with a rare book, or a chance encounter with a well-mounted and presented photograph in an artist's studio, collector's home, or antique shop to realize that, as with all arts, the medium of photography has an upper end to its scale. Photographs produced by thoughtful artists, whether intended for illustration, documentation, or display, reveal all the care for design, materials, and content (the intended meaning or purpose of the work) found in other print media, such as etching, lithography, or engraving. Indeed, photography is merely the contribution of the nineteenth and twentieth centuries to this older list. As works of art, photographs, once understood, should be judged by a set of values similar to those in other media. An outline of these is offered in Chapter 5, "Understanding Photographs and Their Value."

Is the Reproducibility of the Photographic Negative a Problem for Collectors?

Beginners, and those not thoroughly acquainted with the field of photography, often express concern that since any number of prints can be made from a negative, the value of individual works may be affected by the existence of other similar pieces. In practice, the case is quite different.

Until the growth of a substantial market in photography in the 1970s, photographers had no motivation or occasion to make prints in large numbers. Making photographic prints, especially ones of high quality, is both time-consuming and expensive. Without prospective buyers, most photographers limited their editions to a relatively few prints, often even failing to print the number of individual works that would have constituted a complete edition. After the expansion of the market, production of prints was limited for the opposite reason. With the increase in interest in photography, the value of prints was tied in part, as it is in all areas of art, to rarity. As sophistication about the quality of photography increased demand for prints, photographers often chose to limit their production in order to keep the value of individual pieces high.

A third consideration regarding reproducibility, quality, and value is that of the later reprinting of earlier negatives. With the popularity of photography increasing, photographers of stature, such as André Kertesz and Henri Cartier-Bresson, have sometimes chosen in recent years to create new prints of significant or popular works. While this does produce a larger number of prints in absolute terms, these later prints are usually different in nature—for example, in type of paper and level of contrast—from their earlier counterparts. This latter distinction

between earlier and later printings forms the basis of the important concept of the vintage print.

What Is a Vintage Print?

A key feature of the photography market, and to understanding and collecting photography, is the awareness that prints produced earlier—and thus closer to the time a negative was exposed—are likely to be more closely bound to the artist's thinking and habits of the time than those produced later. These earlier prints, commonly called vintage prints, are those most often valued and prized by collectors.

The paradox that new collectors and those educating themselves in the field of photography must assimilate is that older works with all their idiosyncrasies and imperfections are often of more value than corresponding works that are newer and, by contrast, may seem brighter and more consistent. The relative dates of the works being considered will differ—a vintage print by the photojournalist Eugene Smith may date from the 1950s while a vintage work by Edward Weston may have been printed in the 1930s. But the principle remains the same: if a true vintage print, each was printed close to the time it was taken.

Armed with these distinctions, and others gleaned later in the text, it is hoped that a reader will be prepared to face the world of photographs with the knowledge and confidence necessary to enjoy one of the most interesting and fastest growing areas of collecting in the arts today. With this goal in mind, the following chapter will introduce you to the history of the medium and to some of its greatest artists, in order to give an overview of photography from its inception in the early nineteenth century to the complex works of the present day.

2

The Art of Photography

The roots of photography lie in a unique confluence of the history of science and art. Long before photography was conceived, the photosensitive qualities of certain materials had been observed. Indeed, today some dyes in cloth and paper, for example, still fade as readily as they ever did when exposed to light. The result of such exposure is an impression of whatever has been placed on the dyed paper or cloth. During the Renaissance, an apparatus was perfected for the use of artists that focused an exterior image onto the wall of a small room through a tiny opening, enabling a draftsman to draw the image with greater accuracy. The room was darkened to receive the image, and the device was called by Giovanni della

Porta, the Italian inventor who popularized it and published a description of it in 1558, a *camera obscura*, the Italian words for "darkened room." (See illustration.) Together, the concept of an image from nature recorded on a light-sensitive surface, most often in conjunction with the use of a camera, forms the basic idea behind photography.

In the eighteenth century, advances in chemistry and physics associated with the Enlightenment, as well as new demands for visual accuracy on the part of artists and the public, brought together the components that would lead to photography. Their progress was, however, far from uniform. In chemistry, experiments based on the earlier work of J. H. Schulze, C. W. Scheele, Joseph Priestly, and others were under-

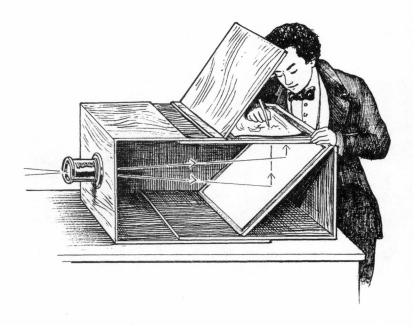

Camera obscura. A precursor and model for the camera later used for photography. Developed in the Renaissance as an aid to drawing, the camera obscura brought an image through a lens into a darkened box.

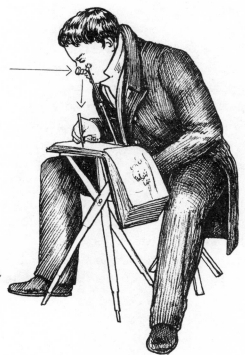

Camera lucida. A drawing
aid developed in the
early nineteenth century,
far more portable and
practical than the
earlier camera obscura.

taken by Thomas Wedgwood, scion of the porcelain family, and
the chemist Sir Humphry Davy to use light-darkened silver
salts in the reproduction of forms and silhouettes for use in
decoration and design. In Davy's published account of their
work, in 1802, it is clear that they were able to record simple
shapes, but not to stop the chemical action of the light on the
silver, which would have preserved the image from fading. In
optics, William Wollaston, expanding on the principles of della
Porta's camera obscura, created in 1807 a far more versatile,
portable, and practical device, the *camera lucida*, for the assis-
tance of draftsmen and artists. (See illustration.)

Of additional note is the invention of the art of lithography
in the last years of the eighteenth century. During its initial

forty years, before the invention of photography, lithography was the preeminent modern medium. In its ability to reproduce art mechanically—printing an image on paper from an original on stone through a process based on the mutual repellence of oil and water—lithography was the precursor to some of the important reproductive and artistic characteristics of photography. Each of these advances, however, while helpful, lacked an important key element essential to the new medium. Optical devices such as the camera lucida, and methods of printing such as lithography, though aiding the artist in accuracy of expression, still only assisted in the production of a handmade image. And images recorded automatically from nature through the chemistry of light-sensitive materials, though appreciated during their brief life, remained unfixed, fading under exposure to more light. It was to these challenges that the inventors of photography responded.

THE EARLY YEARS

The Daguerreotype (1839–1855)

For the public, the beginning of photography dates from the announcement of its discovery by the best known of its inventors, L. J. M. Daguerre, in 1839. This momentous occasion was the result of the cooperative efforts of two men. The earliest work, leading directly to the invention of photography, had been conducted not by Daguerre himself but by Joseph Nicéphore Niépce. As early as 1816 this French inventor was producing photographic images with a small camera. He later achieved permanence of the image through a process of relief printing; that is, creating photographically a plate from which to print an image with ink. Examples of his work, believed by

experts to be the first genuine photographs, date from 1826 and 1827, more than ten years before the announcement of Daguerre.

In 1826, Daguerre, alerted by their common lensmaker, contacted Niépce to learn about his work. For Daguerre, Niépce's experiments held the lure of a fixed image; for Niépce the attraction was the far more artful and precise visual impression obtained by Daguerre with his relatively sophisticated camera. A partnership ensued. Eventually Daguerre succeeded in chemically fixing his extremely fine images on metal. He named the new method after himself. Among his earliest extant works are daguerreotypes dating from several years before his official announcement. Unfortunately Niépce, who died in 1833, did not live to see these beautiful objects.

Artist, showman, businessman, and proprietor of a public diorama which was one of the great theatrical entertainments of its day, Daguerre brought to the presentation of photography the talents of an impresario who understood the value and potential impact of his work. While Niépce had represented the disinterested, retiring, scientific side of photography, Daguerre saw it as a powerful aid to culture and art. In January 1839, having demonstrated his process in secret, he arranged to have it announced to the world at the French Academy of Science by the respected French scientist François Arago. The result was news that both shocked and intrigued the world: a method of making pictures directly from an object or scene by the action of light alone. Daguerre agreed to disclose his process in the summer, in response to an offer by the French government to buy it in order to make it available to the public.

The publication of Daguerre's process provoked widespread public response. Although questioned and even rebuked in some quarters as unnatural or impossible, the advantages of

photography were obvious to scientists, artists, and the public at large. Word of the invention spread quickly. Within days others had tried the process. Within weeks it spread as fast as the speed of the ships and coaches of the day. Within the year photography was being tried with varying results, but always with great excitement and interest, in many places in the world.

Initially, the public was attracted by the precise, jewel-like quality of the daguerreotype image. Its reproduction of the visible world, especially architecture and still life, was stunning, almost magical to a public who had seen nothing like it before. Today, daguerreotypes still have an aura of mystery and revelation that tie them to both history and art. Among the most important practitioners of the new medium were portraitists. In New York, the painter Samuel F. B. Morse was among the first to try daguerreotypy; later it was taken to considerable commercial and artistic heights in that city by the Anthony brothers and Mathew Brady. In Boston, John Adams Whipple and the firm of Southworth and Hawes were the finest practitioners. In Philadelphia, the Langenheim brothers were active; in London, Richard Beard was one of the earliest daguerreotypists, with a successful chain of studios throughout Britain, and, of course, in France itself, the daguerreotype was immensely popular as well.

Besides portraiture, travel and architectural views were important early subjects of daguerreotypy. In Paris, the early panoramic cityscapes of Frederick von Martens are still much sought after today. Even rarer are the fine works of Baron Gros and of the early lensmaker Chevalier. The first published daguerreotype images were travel views commissioned by the French entrepreneur N. M. P. Lerebours, whose *Excursions Daguerriennes*, published between 1840 and 1844, consisted of views engraved by hand from original daguerreotypes taken in Russia, Egypt, and America, among other other sites. The orig-

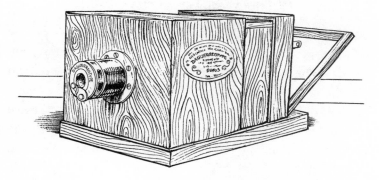

Daguerrean camera. Early cameras were made of wood and were modeled on the camera obscura of the Renaissance.

inals are believed to have been lost, as the engraving is thought to have been done on the original daguerreotype plates themselves.

Despite its success, the new medium was not without its problems. For the many aspects of the visible world, which unlike still life and architecture refused to hold still, the daguerreotype was more difficult to apply. Portraits required long exposures in bright light; a metal brace was often used to hold the sitter in place. (Cartoons of the time portray pained portrait sitters, and amateurs in the landscape encumbered with photographic equipment.) It is no surprise, then, that daguerreotype portraits of freshness and spontaneity are highly prized. Eventually, in light of its limitations, and despite its great initial popularity, public interest in the new experience abated with the introduction of new and more adaptable media. Still, the popularity of the daguerreotype was immense, not only originating a large international business but initiating the first phase of what was to be the long life of the new medium of photography.

Photography on Paper (1839–1870)

The announcement of the discovery of a photographic process in France prompted others experimenting in the field to come forward. The most important of these was the British scholar, scientist, and inventor William Henry Fox Talbot. An habitué of the circle of serious British *dilettanti* of his day, among his many pursuits, ranging from botany to Egyptology, Talbot had been working for more than five years—since the fall of 1833, by his own account—on a method of fixing the image of the camera obscura on paper. News of Arago's disclosure at the French Academy of Sciences of the success of Daguerre, although the details were still unpublished in early 1839, prompted Talbot to immediately lay claim publicly to the results of his own work.

Talbot practiced the important British tradition of investigative science and learning. His colleagues and peers included both amateurs and professionals in many fields, including Sir John Herschel, Sir David Brewster, and Sir Charles Wheatstone, each of whose discoveries would eventually play a role in the development of photography. His own experiments began, however, not as an adjunct of science, but as an aid to his efforts in art. Traveling in Europe, he found his ability to sketch his surroundings (a common upper-class pastime) entirely inadequate. Even when he used the camera lucida, the results, though more accurate, lacked the beauty he saw around him. While he realized that his talent for art might not itself be susceptible to great improvement, he began to apply to the creation of successful images his more promising abilities in optics and chemistry.

After some experimentation, Talbot, like Wedgwood and Davy before him, found that he could record the shape of simple objects, such as leaves and lace, on paper treated with a light-sensitive silver solution. These he called *photogenic draw-*

ings. A few original examples of this work remain in collections and in institutions; occasionally they appear on the market, and are believed to date from as early as 1834, five years before the public became aware of photography. As with the early work of Daguerre, they are considered the genuine incunabula of the new art.

As with Niépce and Daguerre, the challenge for Talbot was the fixing of the image. A number of methods were tried. Final success was achieved only with the suggestion by Herschel of the use of a bath of *hypo*, sodium hyposulfite, today called sodium thiosulfate by chemists, in which to wash his exposed photographic papers. Over the succeeding years, Talbot, who lived into the late 1870s and saw photography develop into an important international business and art, continued to take pictures. While his images vary in purpose and style from the frankly experimental to the consciously artistic, they are often of interest and frequently pleasing in themselves. Despite their rarity, importance, and age, they are still available to collectors on the market.

Of Talbot's several key discoveries, perhaps the most influential was his invention of the *negative*. As his photogenic drawings were direct impressions of an object, in which silver salts were darkened by exposure to light, they appeared with inverted values—the recorded opaque object was light and the exposed background dark. Talbot's insight was to realize that in order to reverse these values he simply had to make a new print from the original. This was the concept of the negative. Although the daguerreotype—a unique direct positive that could only be reproduced by being rephotographed—was by far the most popular of the early photographic processes, the paper negative developed by Talbot, which allowed printing and virtually unlimited reproduction, although not popularized until considerably later, is actually the basis of most of the

prodigious activity we have seen in photography ever since. Eventually, Talbot perfected the negative and printing process on paper, whose results he called the *calotype*, after the Greek word for beauty, or, alternatively, the Talbotype, after himself. Throughout the process, common writing paper, then typically of greater quality and strength than today due to its higher rag content, was sensitized with silver and used for negatives and prints.

As distinguished from the sharp, metallic, silver daguerreotype, early calotypes are often gentle, dark, soft-edged images whose paper support provides an additional reminder of their relation to the world of the print. The muted aesthetic qualities of the calotype in combination with the practical advantages of the paper and negative process, including larger size and the possibility of reproduction, caused the medium to appeal to a new range of artists and professionals. Among the early uses of the calotype were broad, ambitious projects of travel and documentation, especially in France and the Middle East, as well as studies of architecture, portraiture, genre, and landscape work seen in the work of early calotypists in Britain.

The era of the calotype, from roughly 1840–1870, though longer than that of the daguerreotype, included many fewer photographers. One scholarly estimate has put the total number of calotypists at roughly three hundred in Britain and France, the centers of the movement, while by the mid-1850s there are known to have been nearly ninety daguerreotype studios in New York alone. In Britain, a number of calotypists were influenced by Talbot himself. George Bridges, who made 1,700 paper negatives of his travels to the Holy Land in 1846, learned directly from the inventor. Calvert Jones, a friend of Bridges whose travel views of the same time center on the Mediterranean, met Talbot through his cousin, a classmate at

Oxford. David Octavius Hill and Robert Adamson, important early masters who established the first professional calotype studio in Scotland in 1843 and produced the first sustained body of artistic work in the new medium, also learned indirectly from Talbot through Adamson's brother. Some of the best amateurs of the 1840s and 1850s whose work remains, John Dillwyn Llewelyn and Nevil Story-Maskelyne, were members of the inventor's extended family in Wales. Later British masters of this brief but formative period, during which the aesthetics and use of paper photography were explored for the first time, include Thomas Keith, Benjamin Brecknell Turner, and the former miniature painter William John Newton. Significant British calotypists abroad also include the amateurs John Murray and C. G. Wheelhouse, physicians active respectively in India and the Mediterranean in the 1850s, and Linnaeus Tripe and W. H. Pigou, military men active in India during the same era.

In France, despite the ascendency of the daguerreotype, calotype work was of an extremely high quality. In 1850 Gustave Le Gray, a painter turned photographer, published important improvements to Talbot's process that enabled him and others to employ the calotype in a more refined and versatile manner. Other acknowledged French masters include Charles Nègre, Henri LeSecq, Charles Marville, and Édouard Baldus. Victor Regnault, Louis Robert, André Giroux, and Léon Gerard were other important artists, although still less well known today. More recently the calotype work of Barbizon photographer Eugène Cuvelier and his father Adelbert have come to be widely appreciated. Other key topographical and architectural work done in the calotype medium includes that of the French photographers Félix Teynard, Maxime du Camp, and the American expatriot J. B. Greene, active in Africa and

the Middle East in the early 1850s. A group of accomplished calotypists centered at Pau in the Pyrenees included J. J. Heilman, John Stewart, and Maxwell Lyte.

One of the clear advantages of Talbot's process was its reproducibility. From the beginning it was seen by its inventor and others as an aid to publication and distribution of images. To exploit this application, Talbot established early on a printing operation in Reading. In 1844 he began publication of *The Pencil of Nature*, one of the first photographically illustrated books, and later *Sun Pictures of Scotland*, a similar volume devoted to subjects related to the writer Sir Walter Scott. Other early photographic publications include the botanical *cyanotype* work of Anna Atkins. Though entire volumes of these early works are rare, individual prints notable for their bright blue color appear on the market with some regularity.

In France, the outstanding publisher associated with the calotype was Louis Désiré Blanquart-Evrard, whose volumes and individual prints were considered the height of calotype accomplishment. Many artists brought their negatives to Blanquart-Evrard for printing. Due to technical improvements he made that decreased the time for exposure and development, his establishment at Lille (1851–1855) was able to produce relatively large numbers of prints in a short span of time. Their superior quality has left them, even today, often in fine condition.

One of the disadvantages of the calotype process was not inherent to it, but a legal problem. To protect and control his invention, Talbot took out patents whose exclusivity in the end considerably slowed the spread of the process he had developed, including the extension of the process to the United States. Photographs unmade due to legal restrictions will not be of great concern to collectors, but investigating this chapter

in the history of photography can be instructive to those with an interest in the relation of science, art, and human nature.

Collecting Early Photography

Although a relatively new field, collecting early photography has become an important and popular part of the current market. Calotypes are among the most widely available of early media; daguerreotypes of high quality, though often more difficult to find, are appearing in increasing numbers at auctions and dealers. Not to be ignored by those interested in the early era are photography-related work in other media or of particularly early appearance. Among these are the first attempts of Talbot, the drawings and paintings of Daguerre, and the optical and scientific toys, tools, and ephemera of the pre- and early photographic era, as well as those of a more recent vintage. Several exhibitions, articles, and books, such as Peter Galassi's *Before Photography* (1981) have pointed out the relevance to the study and appreciation of photography of paintings, perspective drawings, works in the trompe l'oeil style, as well as other pre-photographic optical-related work.

PHOTOGRAPHY ON GLASS (1850–1890)

During its first dozen years, until 1851, with only a few exceptions, photography was pursued almost exclusively on metal and paper. The daguerreotype, produced on silver-coated copper plates, was the most popular and well-known medium, and the paper negative, originating with Talbot, was the choice of amateurs and professionals partial to its more muted aesthetic properties and particular practical advantages. Inherent

qualities in each process, however, were obstacles to the widespread use of the medium. The daguerreotype process was cumbersome and highly complex. Its plates were expensive and heavy, compared to paper, and only a single image could be made from each exposure. Talbot's paper negative process, on the other hand, although considerably easier and more versatile than that of Daguerre, more pleasing aesthetically to those with a painterly, rather than a precisionist sensibility, and inherently reproducible, lacked the clarity and sharpness of the Frenchman's process.

In 1851, Frederick Scott Archer, an Englishman, published a method of using glass plates in place of paper negatives. The considerable advantages of his process led to its immediate adoption and soon to its widespread use. For the next forty years the so-called *wet plate,* and later *dry plate,* processes on glass became the most widely used in photography. The principal advantage of glass was its ability to record detail better than paper. Earlier attempts to use it, however, had failed for lack of a practical agent with which to adhere a photographic emulsion to the glass. The advent of collodion, a tough and versatile adhering agent invented in 1847 for use in medicine, offered the prospect of a solution. When applied to glass, its sticky surface accepted the photographic chemicals. If developed while still wet, it formed a permanent, flexible, transparent negative.

Originally, Archer recommended stripping off this layer and reusing the glass to make another negative, but soon it became conventional to use a single sheet of glass for each negative. In this form, especially in conjunction with albumen-coated paper for printing, developed at about the same time, the wet plate technique became the staple of professional and serious amateur photographers the world over. Consequently, the wet plate

era, from roughly 1850 to 1890, is one of the most interesting and important in the history of photography.

In many ways, the wet plate era is best defined by the particular uses to which the new medium was put. In Europe, it was soon adopted for pioneering photojournalism, documentation, and topographical work, areas for which neither the daguerreotype nor the calotype was well suited. The British photographer Roger Fenton's early wet plate views (1855) of the Crimean War, as well as those of his contemporary James Robertson, are still classics of the art. In the Middle East and Egypt, biblical, cultural, historical, and literary subjects were the basis of key bodies of work. Other important suites of topographical wet plate pictures, mostly by Europeans, were done not only in India, as with the calotypists, but in China and Japan, as seen in bodies of work by John Thomson, Félice Beato, and the American Charles Leander Weed. Early portraits, landscapes, and still lifes from the 1850s, as well as nudes and work in other genres, established a range of style and accomplishment that were to guide photographers for generations.

The American Civil War was the proving ground for the wet plate process, for photography as a tool of reportage, and for photography as a medium itself. Under the direction of Mathew Brady, and other artists such as his former employee Alexander Gardner, photographers for the first time became trusted recorders and interpreters of important history and events, and by necessity entrepreneurs and directors of large image-making enterprises as well. Nothing before the Civil War had prepared the public for the scope and power of the thousands of images produced. Civil War photography paved the way for other massive photographic efforts, such as those of Franklin D. Roosevelt's Farm Security Administration in the twentieth century, which during the Depression employed

photography in a direct way to inform and uplift the flagging American spirit. Of the many photographers of the Civil War, among the best were Gardner, Timothy O'Sullivan, A. J. Russell, and William Bell. Like Fenton's earlier Crimean photographs, images of the Civil War, highly detailed from the use of glass negatives but unable to record action due to the still slow nature of photographic emulsions, are distinguished by a quiet intensity and melancholy. Many can be appreciated as landscapes or studies on their own merits, apart from the historical significance they may hold.

After the Civil War several of the most important of its photographers went west to work with government surveys and the railroads in the great continental expansion that marked the postwar era. Among these were O'Sullivan, Russell, Gardner, and Bell. The wet plate work of these and others in the West—Carleton Watkins, Eadweard Muybridge, and William Henry Jackson—who had no direct connection with the war, form another extremely important era in the development of photography. Their surviving albumen, and in some cases earlier *salt prints,* of landscapes, buildings, ethnological and other subjects, often large and highly detailed, are much sought after today.

Indeed, use of the glass plate processes worldwide was extensive. Large bodies of topographical, architectural, and genre work were developed, for example, in India by Samuel Bourne, and in Italy by the firm of Alinari and by a number of talented artists such as James Anderson and Robert MacPherson, who specialized in classical monuments and views of historic or aesthetic interest. In France, the firm of Adolphe Braun, known originally for Braun's still lifes, developed a large stock of prints of works of art. In Britain, the firms of Francis Frith and James Valentine were businesses producing large numbers of albumen prints for public sale from wet plate negatives. Many smaller firms and individuals also pro-

duced credible work. Bodies of work were also developed in the Far East, South America, and other distant locales, the best of which are highly prized today.

In cities, and for the general public, the principal and most visible use of the new medium was portraiture. In Paris, Nadar, a self-named inventor and impresario (born Gaspard Félix Tournachon) with an eclectic career, opened a studio in 1853 and produced a body of work important for both the gravity of its style and the historical importance of many of its sitters. Contemporaries judged his peer Etienne Carajat equally good. In New York and Washington, Mathew Brady's portrait studios produced images of Abraham Lincoln whose impact on the public may have changed history itself. Every major city and midsized town had portrait studios, a tradition which in most places continues today, despite the inroads of the instant, personal camera.

The potentially large size of wet plate prints, the flowering of talented photographers, as well as variety of subjects make the wet plate probably the largest single producer of significant photography in the nineteenth century. The wet plate era's impact both in art and in the marketplace is considerable. But, in addition to the prepossessingly large albumen prints frequently associated with the wet plate era, several smaller formats and media were introduced that proved important.

The *ambrotype* was a wet collodion image on glass, which when mounted over a dark backing, became a popular and inexpensive form of portraiture. Ambrotypes, usually small, cased images, are sometimes mistaken by those unfamiliar with them for daguerreotypes; experts will see, however, that they lack the jewel-like metallic surface of the earlier medium—they are also frequently more readily available.

The *tintype* was a collodion wet plate print on metal—usually dark laquer–coated iron—often displaying a grayish tone

without the bright highlights of a paper print. Tintypes were inexpensive and virtually indestructible. They became a highly popular way of recording portraits that could be carried in pocket or wallet without damage or easily exchanged by mail. While they are rarely of great value, tintypes have a charm of their own. The best tintypes, or ones of special note due to their subject, can be of considerable interest to particular collectors or institutions. They are often found in albums manufactured for the purpose of displaying them, or among historical or family collections, ephemera, and correspondence.

Of special note was the advent of the *carte-de-visite*. Again a diminutive albumen print, usually from a glass negative, the popular carte-de-visite, perfected and publicized by the French photographer A. A. E. Disdéri, was a small portrait mounted on a cardboard card, usually with the identifying name and address of the studio or photographer who took it. Cartes-de-visite were, like the tintype, an affordable form of portraiture and were vastly popular in their day. Sometimes produced for public use, sometimes for family and friends, cartes-de-visite, usually taken with a special camera which produced inexpensive multiple images from a single sitting, were collected singly or in albums, and are found today among antiques and ephemera, as well as among collections of photography.

Finally, the *stereograph* constitutes a revolutionary development of its own. This invention, whose principles predate the advent of photography, but nonetheless seem designed to serve it, was an optical device which through the use of a carefully crafted two-lens camera produced a double negative (or in its early stages of development a double glass positive) capable, when printed and viewed through the proper apparatus, of being seen in three dimensions. Technically the stereograph, a small double print from a single glass negative, was an out-

growth of the scientific movements in optics that had led to photography, but as an aspect of popular culture, its widespread adoption and use made it a forerunner of mass media such as television and film. At the height of popularity, stereographs, and their ubiquitous viewer the stereoscope, whose most popular form was invented by the American writer and physician Oliver Wendell Holmes, graced the parlor tables of thousands of households around the world.

Although like other small media stereos are difficult to display, they are fun and relatively easy to collect, and can be viewed directly for enjoyment, just as they were originally intended. Collectors value them for subject matter and technique (such as the depth of the image) as well as for aesthetic qualities, though all of these considerations may come into play, especially in the case of well-known photographers. Stereographs and stereoscopes are still widely available in antique shops and flea markets. Interestingly, these antiquated and quaint views and viewers are the direct ancestors of the toys called Viewmasters enjoyed by many in their youth, and which parents continue to buy for their own children and grandchildren today.

There are a number of masters of glass plate work, photographers whose accomplishment attracts collectors and scholars. Among those not yet named here are Alexander Hesler and William Rau of the United States and the French photographer Eugène Atget, for his late glass plate work, but there are many others. The types of wet plate photographs available, their artists, and their cost vary considerably. These and other factors affecting the collector will be discussed in Chapters 5 to 7. One aspect to keep in mind is that because of their durability some glass negatives, or good copies made from them, can still be printed. The new prints available from, for example, the firms of Alinari and Bourne, and through government agencies—of

American masters such as O'Sullivan, Gardner, and Bell—though often still clear as images are usually quite different in physical and aesthetic quality, altered through the offices of storage, time, and printing. Such prints, unless specifically commissioned, are usually intended more for study and historical reference than for display.

An additional and important aspect of the glass plate era, one more connected in the mind of the public with its subjects than with its technique, and which points toward the future of the medium, is the emergence in photography of the presence of motion. Through the work of Eadweard Muybridge, Etienne-Jules Marey, and Thomas Eakins motion began to be intentionally included in photographs, and conversely, photography employed in the study of motion. In this epoch-making body of work, motion is stopped regularly for the first time, revealing aspects of movement never before seen, and creating through the exigencies of scientific experimentation new formats and types of images that continue to affect styles in the visual arts, including photography itself, to the present day. Such work in photography, in conjunction with advances in the application of optics and physics, also assisted in the development of motion pictures in the years surrounding the turn of the century.

PICTORIALIST MOVEMENT AND THE
ADVENT OF THE AMATEUR (1880–1920)

While the glass plate era of the mid- to late nineteenth century produced important masters and outstanding masterpieces, photography's progress through time was not always matched by advances in quality. In some ways it can be seen to have

been the victim of its own success. The introduction and vast popularity of the tintype, stereograph, and carte-de-visite in the 1860s, for example, brought a new level of production in the quantity of photographic images rarely equalled by their value as aesthetic objects. The profusion of portraits taken by professionals in their studios, often with conventional backdrops and under the hurried pressure of commercial production, yielded truly outstanding work only in the hands of a relatively few artists. As the century neared its close, even topographical work, the views of the pyramids, Athens, Rome, and other exotic locations that had so much interested the public in photography, had become often hackneyed, repetitive, or indifferently printed for the large and relatively less discerning audience it now served.

In addition, technical innovations in photography in the late nineteenth century contributed to changes in its status as an art. The introduction of the prepackaged gelatin dry plate, invented in 1871 to replace the messy and difficult wet plate process, increased the ease of operations in photography, leading to a less discriminating use of its potential. The first halftone reproductions, such as those we see in our daily papers today, appeared in a New York newspaper in 1880 and encouraged high expectations of photographic distribution, largely untroubled by the resulting decline in the quality of its images. The Kodak camera, introduced in 1888, was only the most popular and accessible of a number of smaller, more versatile machines through which thousands, and later millions untrained in art could take photographs of their own. The ease of the Kodak, which required only the click of a button ("We do the rest" proclaimed the company that brought a fortune to inventor George Eastman), transformed photography not only by its popularity but by the emergence of the snapshot, and

with it the notion, unsettling to those for whom the medium was an art, that the eye of the untutored amateur could produce results equally satisfactory as that of the practiced professional or devotee.

Other relevant changes in photography at the end of the century include the effects of capturing motion, as in the work of Muybridge, Eakins, and Marey. Each of these experimental photographers created, in somewhat differing formats, series of images of animals and men in motion that revealed aspects of movement previously unseen, and became forebears to the cinema. At the same time, the new vision created by the anarchic photographic frame of the hand-held camera, no longer secured by a tripod, with its tacit ties to established canons of art, suggested another untraditional, less ordered, less formal approach to composition. In addition, through transportation (trains and steamships) and industrialization (mechanized factories), motion itself had become part of modern life. Extending the realm of the new and unseen, the X ray revealed the interior of solid objects, and the advent of social documentary photography, such as the work of Jacob Riis in the slums of New York, offered an unsettling view of aspects of society also often hidden.

By the later years of the nineteenth century, photography was thus beginning to be perceived by thoughtful artists, critics, and theorists as the province of studio professionals whose endurance and popularity were not always matched by their performance; of technicians revealing an unsettling unknown; and of amateurs, journalists, and scientists whose informal use of the medium had introduced to picture making a new and unfamiliar set of subjects and conventions. The reaction among aesthetically oriented photographers to the results of popular, commercial, and technical changes in photography was to rein-

troduce the constructing and taking of pictures for their own sake. Feeling that the advantages of recorded detail offered by the glass plate era had been exhausted, they turned to imagination and the personal as a basis for their work. In place of the informality, documentation, and aspects of motion that had crept into photographs, they revived artistic guidelines of careful composition, control of tonal range—borrowed from painting and other traditional media—and brought an artistic heightening to their work that approached a sense of myth or dream. In place of the relative uniformity of mass materials and techniques emerging in photography, they offered the results of considered personal interpretation.

The resulting era of reawakened artistic possibilities in photography, lasting roughly from the 1880s through the 1920s and often called the Pictorialist era, is one of the most complex in the history of the medium. Understanding the overall outlines of the Pictorialist movement, as well as the social, scientific, and cultural developments concurrent with it, can be the key to separating its leaders from those who merely followed, and to finding individual pieces and bodies of work of particular interest and value. For clarity Pictorialism will be approached through its roots, its formal beginnings, and the historical models that preceded it.

The roots of Pictorialism extend back to the late 1850s and the work of British photographers Oscar Rejlander and H. P. Robinson. Their carefully constructed photographs, and the theories that accompanied them, were a conscious and highly orchestrated attempt to bring the tenets of the respected fine arts into the new and somewhat unruly world of photography. Rejlander and Robinson sketched out on paper preconceived images, often of sentimental subjects, and then constructed them in pieces from photographs of posed models and recorded

scenes. The resulting negatives were carefully masked and printed to produce a single *combination print*, related in aesthetics and compositional technique to the tradition of painting and printmaking. The intention of the artist and its expression were believed to be of greater importance than the purely photographic integrity of the work. The outspoken Robinson in particular became an important fixture in the ongoing discussions of photography among artists, critics, and theorists of the medium. For a long time new pictures remained available from the photographer on a regular basis; his book *Pictorial Effect in Photography* (1869) continues, for its clarity on Pictorialist issues, to be a key text in the history of art photography after more than one hundred years.

The formal beginnings of the Pictorialist era are often seen in the writing and work of the British photographer Peter Henry Emerson. For Emerson, the focus on the artist advocated by predecessors such as Rejlander and Robinson was correct, but the results of their work were far too contrived, lacking the cohesion and conviction he judged necessary to a complete artistic statement. In *Naturalistic Photography* (1889) Emerson, trained as a physician and well versed in the literature of science and nature, emphasized the importance of natural light, poses, and settings. Although he carefully controlled all aspects of the production of his photographs, his work differed from the work of predecessors in that the various components of his compositions were all recorded in an individual exposure at a single place and time. Artful in the tradition of conscious intention fostered by earlier practitioners, they were naturalistic in their commitment to reproducing scenes available only in the natural world itself.

Emerson's relation to what came to be called Pictorialism lay in his insistence on artistic intent and control, as well as in

moving toward a relatively more natural, scientifically based, and less contrived balance between subject and technique. (In addition, his influence extended to other, later work beyond the Pictorialist period through his insistence on the role of the camera and its limitations over the manipulative abilities of the hand of the artist.)

The works of Emerson most often seen are the *gravures* and *platinum prints* from his published works. Because of their influence, these well-known images, like the later gravures of Stieglitz's *Camera Work,* or Talbot's earlier calotypes from *Sun Pictures* and *The Pencil of Nature,* have a strong historical as well as aesthetic value. Emerson's subjects, often landscapes of outdoor life in Britain, especially boating and farming, though radical in their naturalistic reaction to the more formal prevailing photography of the day, now strike us as comfortably related to a familiar range of nineteenth-century Barbizon and Pre-Raphaelite painting.

At the height of Pictorialism in the decades surrounding the turn of the century, photographers moved away from the visual literalism of Emerson to extend even further the artistic license he had encouraged. Emerson himself publicly recanted his earlier theories. Eventually, naturalism itself was seen to be too rigid and traditional in scope. The majority turned to such clear signs of artistic involvement as handmade prints, rough-textured papers, and the addition of color to their images, much in tune with the return to craftsmanship evident in other media of this era.

The historical models for this aspect of Pictorialism return us to the early work of Talbot in the 1840s; his most important contemporaries, Hill and Adamson in Scotland; and a little later, in the 1860s, to the work of the British photographer Julia Margaret Cameron. All of these artists embraced a softer image

(as distinguished from the aesthetics of the daguerreotype and the conventions of the glass plate negative), allowing a far more personal interpretation of their subjects. In a world in which photography was moving toward harder, clearer, more impersonal definition, the Pictorialists turned to a softer, more malleable aesthetic and to a richer presentation of their subject as a better medium for individual expression.

The resulting prints were often in soft focus, a subjective approach frequently reinforced by content verging on the sentimental. Among the best-known works and photographers of this era are the striking portraits of Heinrich Kühn and Gertrude Käsebier, the studied genre scenes of Clarence White, and the mystical landscapes and metaphorical subjects of the Berkshire recluse George Seeley. In Britain, in 1892, the group called the Linked Ring was formed by Robinson, George Davison, and others to institutionalize, through tight control of exhibitions and recognition of painting as an appropriate model, the return to art photography. This influential organization disbanded after some fifteen years.

The increased activity in photography during the Pictorialist era was supported by a number of public programs. Exhibitions and salons throughout Europe and America were recognized as important forums for new work and for the promotion of particular groups' aesthetic and critical agendas, which were in turn presented and discussed in the relatively large number of publications of the day. As national and international communication improved, the pace of aesthetic and critical dialogue speeded up. In the early years of photography change was tied mainly to innovations in technology, materials, and equipment, but by the end of the nineteenth and early twentieth century it had become largely a matter of influence, opinion, and choice.

The importance of the Pictorialist period, in conjunction with

the relatively large number of amateurs and professionals active during the era, and the variety and quality of prints available, make Pictorialism an exciting area for collectors. With the considerable amount of surviving material, even beginners can find prints of value at a reasonable cost. Those with a more developed taste will find entire oeuvres and schools in need of study and care.

THE PHOTO-SECESSION (1902–1917), EXPERIMENTAL, AND STRAIGHT PHOTOGRAPHY

The principal force succeeding Pictorialism was that of the Photo-Secession movement and the emergence of experimental and straight photography. At the center of this movement was Alfred Stieglitz. American-born and European-educated, Stieglitz was well positioned to bring recent European innovations in the arts to a far wider audience. As Pictorialism reached a point of saturation with the personal and emotional, Stieglitz, himself first a Pictorialist whose talent had been recognized by Emerson, encouraged the shift toward simplification and abstraction already emerging in advanced European art. Working through camera clubs and their existing exhibitions and publications, reaction to his radicalism soon caused him to strike out on his own. Between 1902, with the founding of the Photo-Secession (named for its European predecessor), and 1917, the closing of his gallery, known as 291, Stieglitz was a focal point for change first in photography and later in painting. After the closing of 291 he remained an active force in the art world for many years.

Stieglitz was responsible both for encouraging changes in the overall framework of photography as a field, especially in intensifying the pursuit of its recognition as an art, and for the

introduction, through his gallery, exhibitions, and publications, of individual photographers of merit. These changes and choices were more than Stieglitz's personal views, however, and later came to be seen as reflecting and supporting widespread developing attitudes on the part of the photographers of his time. The emergence of a simplified style, leaning toward the values of abstraction, was a growing reaction to the ornate, sentimental, at times claustrophobic personal approach that preceded it, and the attention to sharpness and detail a response to the hand-worked printing influenced by the Romantic era in favor at the turn of the century. These anachronistic aspects of artistic style did not suit an emerging aesthetic based on the severity of modern industrial production and design. With a growing disaffection of artists and intellectuals toward the overbearing legacy of nineteenth-century industry and science, it is no surprise that the photography of the early twentieth century should begin to match in character the liberating boldness and abstraction of contemporary architecture, furniture, and painting.

The dozen years between Stieglitz's return to America in 1890 and his founding of the Photo-Secession were highly turbulent. Cities were vibrant with new building and technology. The automobile emerged, and soon the airplane. In photography, a new vision had begun to assimilate the effects of captured motion, the anarchy of the hand-held camera, and the results of other scientific and social science work. The emerging style of the Photo-Secession reflected these changes. Though the secession began as a group of Pictorialists, including Frank Eugene, Heinrich Kühn, Gertrude Käsebier, Joseph Keiley, Edward Steichen, and Clarence White, its work, as reflected in exhibitions and its elegant publication, *Camera Work*, moved increasingly away from the Victorian, bucolic, and personal toward a vision in which abstract design and contemporary

subjects and treatments prevailed. In some cases, photographers focused on the new, streamlined products of industrialism, in others they captured images in which this same clarity was found in more traditional objects and scenes. Transitional works of this period, such as are found, for example, in the work of Alvin Langdon Coburn, are relatively easy to identify, as they often combine an older, softer Pictorialist style with a newer industrial or urban subject, or the reverse.

By the time the movement had run its course, the groundbreaking Armory show in 1913 brought modernism to American shores. The last issues of *Camera Work* were devoted to the increasingly abstract work of Paul Strand, and before him to that of other photographers expressing modernist values, among them Karl Struss, later a cinematographer, and Stieglitz himself. With the emergence of strong modernist photographic personalities for whom form and design were paramount, such as Sheeler, Edward Weston, and Edward Steichen in his later work, the transition to more simplified formalist values was complete. The founding of the group f/64 in 1932, which included among others Weston, Ansel Adams, and Imogen Cunningham, put a public stamp on the new, objective, carefully calculated visual values—values which by then had already been further extended, in Europe, to create the more overt and radical modernism seen in the abstractions, cameraless photograms, mixed media collages, and radical viewpoints of Lazlo Moholy-Nagy, Alexander Rodchenko, and the American expatriate Man Ray.

The principal legacy of the transition from Pictorialism to the modern era for representational photographers working with traditional subjects was the style of straight photography, an unadorned, unaffected, modernistic approach to the medium that was the polar opposite of Pictorialism's crowded, tactile, late Victorian view. With its graphic clarity—responsive

to printing and publication, and providing an aggressively declarative presence in exhibitions—straight photography has remained, either on its own or as a component, an important aspect of photographic style. For photographers working toward the pure abstraction and more radical view that had entered the arts through Cubism and its allied revolutions— among them Expressionism, Constructivism, and Surrealism— the photogram, solarization, collage, and other experimental techniques pioneered in the early modern era offered a new set of tools with which to work.

DOCUMENTARY PHOTOGRAPHY AND THE ADVENT OF THE MODERN ERA

While straight photography and new experimental techniques reflected artists' personal responses to end-of-the-century atti-tudes and changes, a related development was the application by photographers of an equally direct and effective style to serve the needs of the society around them. Since early in its history, photography had served not only artists but also reporters of different types. Among the outstanding large enterprises undertaken had been the pioneering French docu-mentation of architecture (1850s), the recording of the American Civil War (1861–1865), and exceptional bodies of topographical, ethnographic, and travel work. The thorough documentation of works of art had been undertaken by firms such as Alinari and Braun. Social issues had been occasionally but relatively rarely addressed through photography first in daguerreotypes, though more often in hand adaptations of them, such as in the woodcuts made from the work of one of Daguerre's first licensees, Richard Beard, which illustrated the extensive publication *London Labour and London Poor,* issued

between 1851 and 1864. Later, also in Britain, John Thomson provided a series of photographs, taken specifically for the purpose, to illustrate *Street Life in London* (1877). As the new century approached, the Danish-born American Jacob Riis produced his epochal study of the slums of New York, *How the Other Half Lives* (1890). After the turn of the century Lewis Hine expanded the documentary tradition with his illustrated critiques of immigration and child labor in America, initiated shortly after 1900.

Another factor affecting photography at this period was the recognition, through the new, radically simplified vision of the straight photographers, of the relevance of previously neglected forebears in the documentary tradition. The young Berenice Abbott and fellow modernists in Paris were responsible for bringing to light the highly influential work of Eugène Atget. In America, publications related to the celebration of the fiftieth anniversary of the Civil War (1911) prompted the youthful Walker Evans to recognize the importance of the work of Mathew Brady and the photographers of his era. In addition, the sobering effects of the First World War worked to purge the remaining personal emotionalism from much photographic work.

Again, technical changes played a role. While many early documentary photographs had been published, the form they took until the late nineteenth century was that of original photographs tipped by hand into a printed text or onto the stiff panels of portfolios and albums for distribution or sale. The development of more versatile cameras at this time suggested to photographers a new range of subject matter, and improved, automated mass printing techniques offered a potential impact on larger audiences. The resulting changes in visual culture, which brought photography out of the privacy of the parlor and into the daily life of European and American culture, were

unequaled until the arrival of electronic media later in the century.

The changes in photography were embodied in a burgeoning of journalistic and reportorial activity on several fronts. Through the halftone and the manufacture of inexpensive pulp papers, on the one hand, prepossessing photographic images began to dominate the presentation of news. With the development of more exacting printing methods and better papers for magazines, on the other, the publishing of photographic images of fashion, advertising, and science took on professional interest, stature, and quality impossible before. These changes led not only to the new career of news photographer, of whom the best known is probably New York's Weegee (born Arthur Fellig) but to work such as that of Edward Steichen and Baron de Meyer in fashion and of Paul Outerbridge and Anton Bruehl in advertising. In journalism, Margaret Bourke-White, whose striking monumental images of architecture and machines were often published as part of the photo-essays pioneered by the new newsmagazines, of which *Life* and *Look* became the most enduring, played a similar leading role. In the area of science, the world became equally fascinated by the photographs of Harold Edgerton, a researcher who seemed to capture the spirit of the twentieth century in his widely published, and seemingly impossible, instantaneous strobe-lit shots of a football being kicked and of the motions of a tennis ball being served—photographs that captivated the public, and in turn served to affect the work of artists as well.

During the Depression the documentary style was also adapted to the uses of the government in the large photographic projects undertaken in part to record the changes of the time and in part to encourage the American people during an exceptionally difficult era. In this area, the careers of Walker Evans, Arthur Rothstein, Ben Shahn, and Dorothea Lange offer

examples of the highest quality work. The highly positive, supportive approach apparent in much (though not all) federally sponsored work of the time embodied a mood in photography and an institutional strategy on the part of the government. It continued into World War II with the work of the Office of War Information—work only recently recognized, and still little seen. The optimistic quality of this work, in concert with the now highly popular newsmagazines, which reported on the war through the lenses of such outstanding, and often disconcerting, photojournalists as Robert Capa and W. Eugene Smith, paved the way for the upbeat American photography of the 1950s still familiar to many today. In Europe, where the effects of the war were far more devastating and direct, the prevalence of a straight documentary approach to photographic work lingered for many years, as it does today, as a probing and apparently disinterested artistic and journalistic style quite different than that generally found in American work.

AFTER 1950

At midcentury, with the close of the war and the growth of the very different postwar world, we encounter a new set of conditions and attitudes that separate work in photography during this period from that which went before. In the area of publications, photography continued to successfully expand its role in the presentation of news, editorial content, and the advertising of products that supported them. In the area of artistic expression, the Depression and the war had left a legacy of anger, disorientation, and discontent. Like other artists and thinkers, photographers found the contrast between the wrenching experiences of the previous decades and the bland materialism that followed difficult to assimilate.

As a result, the work of this period reveals considerable negativity and questioning. Photographers in the postwar era often portray or symbolize in their subjects the dislocation they felt. Among those with a reportorial or documentary approach, Robert Frank is frequently considered the most important and influential. Frank, a Swiss-born American who later spent considerable time in Canada, traveled the United States on a Guggenheim fellowship, producing in 1958 the book *The Americans,* published first in Paris. His direct, sardonic, unflattering view of postwar America, presented with little regard for traditional aesthetics, inspired a school of street photographers and unsettling interpreters of the American spirit, ranging from the unpredictable Garry Winogrand to the uninhibited and inquisitive Diane Arbus, who set a new tone for the era. Among photographers pursuing the more purely expressive artistic goals that had emerged before the war, the work of photographer, writer, and teacher Minor White portrays, in that different vein, a highly personal, mystical, symbolic, at times surreal approach, which was later adopted by a number of his students. Other important developments during the postwar period include the careers of Harry Callahan and Aaron Siskind, photographers who in their different ways explored through the medium of photography the often intellectually difficult minimalism and abstract expressionism popular in the painting of the 1950s and 1960s. In Britain, the later photographs of Bill Brandt, nudes distorted almost to the point of abstraction, and printed on the rough-grained, high-contrast papers popular in the period, register some of the painful personal changes the artist felt from the time of his prewar, socially concerned documentary work.

In a more positive vein, one of the important photographic events of the postwar period was the outstanding and highly

popular exhibition *The Family of Man,* mounted by the Museum of Modern Art in New York in 1955. This upbeat, encyclopedic effort created by Edward Steichen in his role as curator (following several earlier careers, including those as photographer and editor), introduced the public to the emergence of photography as a focus for museum exhibitions and as a medium mirroring the attitudes of its subjects as well as its artists. The more than five hundred photographs in the exhibition, culled from some two million Steichen said were submitted, arranged in a popular, informal format reminiscent of journalism or film, although far from being entirely positive in content, constituted for viewers a confident exemplar of the powerful unifying and educative force the medium of photography could provide.

In the 1960s, the mood of criticism directed at both society and the world of art continued through the purposefully disoriented street photography of Garry Winogrand and others, as well as in the related but more studied and personal work of Lee Friedlander, whose more formal and subtle treatment of American monuments and scenes has led him to be considered by many a modern master of the medium. The mood continued with the movement dubbed, in an important 1975 George Eastman House exhibition, the "New Topographics." Through this exhibition, an assemblage of photographers were identified who brought the critical view of American land and life into the present by addressing a range of contemporary landscape subjects—including unsettling aspects of housing, development, and the social habits of Americans—unrecognized as sources of serious artistic comment since the Depression. While these artists, who included Robert Adams, Lewis Baltz, and Joe Deal, did look to the earlier generation of Walker Evans and his Depression-era peers as models for their work, their more overt

concern for conveying irony reveals the different national and international mood of their time.

The inclusion of Stephen Shore in "New Topographics" indicates the new credence given to color work in the postwar era. While color processes had been known for over one hundred years, and available commercially after 1900, it was not until improvements in photographic materials, printing, and publishing were made later in the century that color became popular among working photographers. Although a body of color work exists from the Depression era, this aspect of the medium did not reach the public until the advent of color newsmagazines and the exhibition and publication later in the century of the landscape work of artists such as Eliot Porter, Stephen Shore, and Joel Meyerowitz who associated themselves strongly with color work. Ironically, the ready availability to the public of color film and prints, through Kodak and the revolution in home and family photography, probably worked to devalue this new direction in serious artistic photography, as the portable camera and easily processed films had done to black and white photography at the end of the nineteenth century.

As the twentieth century moved into its final quarter, photography found itself in a new role. Through the offices of artists such as Robert Rauschenberg and Andy Warhol, photography had joined a new artistic arsenal that included a wide array of sources and materials that seemed to span all subjects and media. Photographic images became part of paintings and prints, and photographic styles continued, as they had since the nineteenth century, to influence the aesthetics of other media. Best known of these mixed media productions are perhaps Warhol's silkscreened and painted works based on photographic portraits and other images from the public media, and Rauschenberg's more complex pieces, which often employed

photographic images transferred directly onto paintings or lithographic plates from newspapers and magazines. Other such prominent uses of photography are as stage sets or props for the new performance work which was developing in other media.

In many cases these often avant-garde enterprises constitute art about art. A logical extension of this movement in recent years has been the use of photography to document performances, playing no other part than a witness. This of course returns photography to its original role of recorder of scenes and events. One aspect of this role that observers and professionals alike have found disconcerting is the postmodern impulse to use photography to comment directly on the medium itself. In the work of Sherrie Levine, Richard Prince, and others, photographs themselves are re-photographed and presented as the finished work of the later artist. In a similar vein, early work, often photographic, is parodied or addressed through carefully constructed new photographs invoking the imagery of an earlier period or style, as in the photographs of Cindy Sherman or David Levinthal.

To the collector, all of this complexity only adds to the excitement and challenge of the field. But if collecting in the current era interests you, prepare to spend considerable time with the publications, exhibitions, and scholars of the contemporary era, in order to be able to sort it all out.

SUGGESTED READING

A number of monographs exist on the various eras and artists mentioned here. Among general histories, the standard sources have traditionally been Beaumont Newhall's influential *History of Photography* and the more complete *History of Photography* by

Helmut and Alison Gernsheim; each has been periodically revised in several editions. More recently Naomi Rosenblum has tried to cast a somewhat wider net in her *World History of Photography,* and, as one of the large number of books to emerge from the photography anniversary celebrations of 1989, John Szarkowski's *Photography Until Now* offers a carefully considered and somewhat more personal point of view. Both of the latter volumes are more explicit about technical issues that affect the history of the medium.

3

~

MEDIA AND TECHNIQUES

Photography is a complex medium, with many variations on the processes through which artists and professional photographers arrive at their finished work. This chapter will offer a brief introduction to the major processes and techniques in photography, and their principal variations, with particular emphasis on how these processes can help identify photographs of differing periods, artists, purposes, or styles. There are many technical guides to photography. Readers wishing to know more about such topics as cameras, film, or the complexities of development and printing are referred to the bibliography for more precise information.

THE BASICS

All photography is the process of producing images on a photosensitive surface through the chemical action of light or,

as in the case of the X ray, other radiant energy. To produce the photographs created by artists and sought by collectors, a common set of materials, techniques, and processes is involved. Variations on these basic components create specific types of negatives and prints with which those interested in the field should be familiar.

First, in the typical photographic process, as in painting or in other graphic art, there must be a base, or *support,* on which an image may be produced. In photography this might be the metal plate of a daguerreotype, the paper of a calotype negative, the glass of the collodion technique, or the celluloid of later roll film. The support is the material on which the original recording and processing of the image take place.

To receive the image, the support must be sensitized. Generally this is done through the introduction of an *emulsion,* photosensitive chemicals applied to the support. When the sensitized support is exposed to light, an *image* is produced, most often through the action of the light on silver salts, although media such as other metals, materials, or pigments are also used. In the case of most photography, the image on the support will be used as a *negative* to produce prints. In some cases, however, as with the daguerreotype or the early paper method of the French photographer Hippolyte Bayard, only a single image—or *direct positive*—is produced, and can be reproduced only through a complete repetition of the process, or copying by some other means.

Most photographic images are exposed in a *camera.* The internal optics and mechanics of cameras constitute a study of their own. Among the most important components are the *lens,* through which the light entering a camera is focused on the negative, and the internal configuration of the camera itself. Lenses vary in construction in order to produce images of differing types; cameras also differ considerably, ranging from

small boxes with a single primitive opening for light, to complicated, often large machines with variable focal lengths and aperture, internal mirrors, and other mechanical and optical complexities. Beyond the individual talent of a photographer, the choice of camera and lens can have considerable impact on the image produced. It should be noted that, as in the case of photograms, made by placing objects directly on a photosensitive surface, a genre of *cameraless images* exits as well.

Once an exposure has been made, the negative or direct positive in most processes must be developed. *Development* is the process of bringing out the image latent on the emulsion-coated support, usually through a chemical bath, and *fixing* it so that the chemical action that produced the image ceases. In some cases, like the iron-based cyanotype, the bath is simply water to wash away excess salts, in others it is a complex mixture of chemicals with specific reactive properties. In developing, time, temperature, and other factors may be employed to influence the chemical results.

By employing the negative a *print* is produced. This can be done simply by placing it in contact with photosensitive paper or other print support (a *contact print*) in sun or other ultraviolet light, which will produce an image the exact size of the negative. In later processes, especially in the twentieth century, the image is frequently *enlarged* in the course of printing, a process that may also include *dodging, solarizing, cropping, vignetting,* and other personal adaptations of the image. After the development of the print, additional *toning* or *tinting* may be done, which affects the print's overall color and tone. Later, a print may be *spotted* or *retouched* with brush or ink to hide imperfections, or even *colored* or *painted* if desired. In some cases, notably in early photography, printing is done directly from the negative (*printing out*) without the extra step of developing.

Finally, photographs are often mounted. *Mounting* may

Stand for holding printing out frames. Such frames
were used in production of multiple quantities of
commercial prints, as well as by prolific amateurs.

include attaching the often fragile photograph to a firmer mount, frequently of cardboard, usually with glue, or it may be *matted* and perhaps placed in a frame. Daguerreotypes, ambrotypes, and other non-paper images are usually placed in small boxes or *cases* for protection. It is worth noting that while most photographs are intended to be mounted in some way, many do not reach that stage. As with the family snapshots that lurk around our houses for years before finding an appropriate album to call their own, the productions of artists or commercial studios, for reasons of time or money never completed and presented, are often found in an unmounted state.

EARLY TECHNIQUES

The Daguerreotype (1839–1855)

Daguerreotypes, the first photographs known to the public, are produced by a direct positive process; no negative is used, and the photographic image that emerges is unique. To produce a daguerreotype a copper sheet is coated with silver; the surface of this *plate* is then buffed to a high polish. The plate is suspended over iodine in a closed container; rising fumes combine to produce silver iodide, a light-sensitive substance, on the plate. Transferred to a camera in the light-proof holder common before the invention of roll films, the sensitized plate was frequently exposed, as in other early photography, simply by removing and replacing a cap over the lens. For development the plate was suspended in mercury vapors, and the image fixed in a bath of salt or hyposulfite of soda. Daguerreotypes were often toned (further chemically treated) to achieve a desired overall color, as well as to improve the clarity and permanence of the image. They were frequently brushed lightly

with color as well, as is often seen in the skin tones, apparel, or accoutrements of portrait sitters.

The daguerreotype image is very finely detailed; this and the mirror-finished plate give this form of photography its characteristic look. Among the sought-for qualities in daguerreotypes, besides high polish and good detail, are delicacy of coloring, size, and the interest of the image. As daguerreotypes were typically small, a "full plate" being only $6\frac{1}{2}$ by $8\frac{1}{2}$ inches, and many produced as half, quarter, or sixth plates ($4\frac{1}{4}$ by $5\frac{1}{2}$ inches; $3\frac{1}{4}$ by $4\frac{1}{4}$ inches; $2\frac{3}{4}$ by $3\frac{1}{4}$ inches), large ones of good quality are rare. As long exposures were often necessary due to the slow reaction time of early photographic materials, images that successfully incorporate delicate lighting, atmospheric effects, and natural poses and expressions of sitters are highly prized. The early use of daguerreotypes to document such curiosities as profession, avocation, and trade make images with activity or occupational props of great interest to certain collectors. The most common subjects for daguerreotypes are the portraits that were the principal use of the medium. Some recording of architecture and specific topographical subjects of the time (the California Gold Rush, the Crystal Palace in London) are also found, as well as the more widespread common impulse to record a view of a favorite animal, carriage, or home itself.

Daguerreotypes are susceptible to damage through abrasion (rubbing) and other signs of handling and cleaning. For this reason they were always presented in cases. The cases are often enhanced with molded decoration and can be of some interest themselves. In considering the condition of a daguerreotype, it is important to note by its condition or other signs whether it seems to have ever been removed from its case, or switched to a new one, which can make further research and identification

Typical arrangement of elements for cased images.
Right to left: inset metal frame,
glass cover, mat, image,
case, and cover.

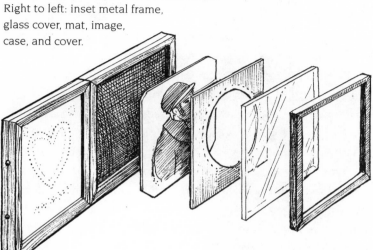

of photographer and subject difficult. Many daguerreotypes
have some mild abrasion. The best have little or none. Pieces
with major scratches or marks from handling must have
images of considerable rarity or importance to be considered.
Some familiarity with daguerreotypes and their makers, as
well as an understanding of the particular source of the work,
will often enable a collector to tell whether a particular plate, its
attributed artist, and the case in which it is found all seem to
match in a credible way. Because early cameras were of simple
design and no negative was employed, daguerreotypes from
the early years of the medium are often reversed, or mirror
images. This can be of use in dating a piece, or attributing it to
a particular photographer on the basis of the type of equipment
used. Later cameras incorporated mirrors to reverse the image
back to its normal form.

Photography on Paper (1839–1870)

William Henry Fox Talbot, inventor of photography on paper, was responsible for a number of important discoveries and innovations. The earliest and most influential, along with that of the negative, discussed in Chapter 2, were the photogenic drawing and its later improvement, the calotype. He also developed one of the earliest processes for photoengraving.

Photogenic drawing, with which Talbot did his earliest successful experiments, was at first a technique for producing cameraless images. A piece of common writing paper was dipped in a solution of water and table salt (sodium chloride) and dried. When brushed with silver nitrate, a light-sensitive substance, silver chloride, was produced. When placed in the sun, this prepared paper recorded any object placed on it by darkening where the silver salts were exposed, and remaining light where they were not. Talbot watched, and when the image was sufficiently distinct, stopped this early printing process. His primitive fixing agent was a second bath in salt. A number of such early images exist, frequently of leaves, lace, and other small objects. Because the process was imperfect, colors and condition of the images vary considerably. The tonality is reversed: a dark leaf appears light in a photogenic drawing and the exposed (lighted) area dark. Later Talbot put his prepared paper into small cameras to capture more conventional subjects and scenes. The recorded image was used to make a second print, which reversed the values (dark to light, light to dark), a process that signals the origin of the negative. He experimented with other chemical fixing agents as well, including the sodium hyposulfite suggested to him by Sir John Herschel, the basis of the "hypo" in common use among photographers today.

The calotype, invented in 1840 and patented in 1841, incorporated improvements to this earlier process, and became the most popular and widespread of Talbot's techniques. In this process he increased the light sensitivity of the chemicals he used, and introduced the *developing out* of negatives. Again the paper was brushed with silver nitrate and dried. In low light the paper was floated on a solution of potassium iodide, which produced light-sensitive silver iodide, then dried again. Before exposure in a camera, a mixture of silver nitrate with acetic and gallic acid was applied to the paper; when used damp, a *latent image* was recorded on the paper. To develop this potential negative (sometimes also enjoyed and sold today as a unique print of reversed values), it was dipped again in the solution of silver nitrate and acids, after which an image appeared. This was fixed in a bath of water and then of bromide of potassium. A final water bath, followed by drying, removed extraneous chemicals. In his later processes Talbot used the hypo suggested by Herschel. Talbot then printed out his negative in the sun on a new sheet of photosensitized paper, sometimes after waxing it to improve its translucence. This returned the reversed values of the negative to their correct and final state in the print.

In the first years of the calotype process, simple salted paper was used, as described; the resulting works are called *salt prints*. Later improvements included albumen-coated papers (*albumen prints*), as well as papers coated in *gelatin* and *collodion,* and a more thorough sensitizing and waxing process for negatives, the *waxed paper process,* invented and popularized by the French photographer Gustave LeGray, which considerably increased the clarity of the negative and artistic potential of the final image.

Around Talbot and his circle of scientific peers grew a sec-

ond circle of amateurs and artists fascinated by his process and its potential contribution to art. The rough, dark, soft-edged image of the calotype, so different from that of the daguerreotype, attracted painters and dilletantes, as well as some who would become professional photographers. Among the first to produce a serious body of calotype work were the Scottish team of Hill and Adamson, whose rich reddish-brown prints, produced between 1843 and 1848, are today often distinguished by a characteristic fading at the edges. Other calotypists are to be found among the best of the early British and French photographers, and are well represented, if less frequently than those of the later glass plate technique, in travel and topographic work as well. Important groups were centered outside of Paris at Sèvres, in India, where British influence was strong, and in Pau, in southern France, as well as in sophisticated urban centers such as Edinburgh, Paris, London, and Rome. Notably, calotypes were virtually unknown in the United States.

With increased production by photographers, especially through commissions and the desire to publish images more widely, the printing of calotypes became an art and a profession of its own. Talbot was the first to set up a printing operation. His Reading, England, establishment produced several early photographic books and printed from negatives for a number of early calotypists. In France, the establishment of Blanquart-Evrard at Lille (and later briefly on the Isle of Wight) provided the highest standards and largest volume of production, as well as introducing important improvements that speeded the process of printing. When assessing the quality of the works of great calotypists such as Édouard Baldus or Gustave LeGray, the role of the printer, whether the photographer himself or another professional, needs to be considered, as

indeed it does with all printed photographs and graphic art. Other considerations are delicacy and evenness of tone, and the care given to bringing out detail in a medium in which this is often difficult to achieve.

Another type of early photographic print that emerged from Talbot's circle was the *cyanotype*. This characteristically blue, or cyan, print on paper substituted iron salts for those of silver and was produced by a process of oxidation. Being considerably simpler, and requiring only a water bath for development, it was employed by amateurs and others seeking a simple means of reproduction. Though its striking deep blue color limited its aesthetic applications, its use in botany, as in the volumes of British flora assembled by Anna Atkins beginning in 1843, produced some very attractive works. It is best known today as the original source of the blueprint process by which architectural and other technical drawings are reproduced. Albums and individual prints are sometimes found in which photographers used the medium in the same way—to record images for study or archival use. Occasionally, both earlier in the century and now again in the current era, the cyanotype is employed for its aesthetic value alone. As a non-silver process, cyanotypes are unusually resistant to fading.

An additional form of print on paper, the direct positive process of Bayard, was also developed in the early years of photography. As relatively few of these prints are known, their role in collecting is extremely limited.

It is also important to know that with the revival of interest in early photography related to turn-of-the-century aesthetic movements, some calotype negatives, including those of Hill and Adamson, were reprinted in somewhat different form. Some familiarity with the originals will allow collectors to distinguish most new prints with little problem. In museums and

galleries, such new prints are often labeled as such, although unfortunately not in all cases.

PHOTOGRAPHY ON GLASS (1850–1890)

Succeeding processes on both metal and paper was the introduction by Frederick Scott Archer of wet plate collodion negatives on glass, a method first published in 1851. Glass plates were desirable for their permanence and superior transparency; they combined the reproducibility of paper with the potential for longevity and detail found in the method of Daguerre.

The key to the wet plate process was the invention of collodion, developed shortly before as a tough and flexible material for use in medicine. Collodion was based on guncotton—cotton soaked in nitric and sulphuric acid—and dried. In the glass plate technique, guncotton was dissolved by the photographer in a mixture of alcohol and ether, to which potassium iodide was added. In preparing to take a picture, the resulting thick collodion was poured on a clean glass plate. While wet it was bathed, in darkness or low light, in silver nitrate to create light-sensitive silver iodide, then moved to the camera where it was exposed while still wet, giving the process its distinctive name. The damp plate was developed in a solution of pyrogallic and acetic acid. The image, then permanent, could be printed at any time.

Despite its aesthetic and reproductive appeal, the wet plate process was complex and difficult, and though it became widespread and its use routine, its important aesthetic use required considerable attention and care. Work outside the studio required a portable darkroom and all the equipment to make it work: baths for immersing the negatives, containers of chemi-

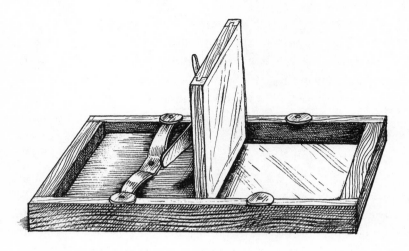

Printing-out frame. Glass-fronted wooden frame for the production in sunlight of prints from negatives. Frame opens at back for insertion of negative and paper and for checking on development of print. Pressure holds print and negative firmly in place to avoid blurring of image.

cals, protective crates for the negatives. (See illustration.) Topographical photography often involved trains of horses or mules loaded with supplies for the days or weeks of work ahead. Working conditions were an important factor; dust or grit on the glass plate was sealed in by the collodion, and thus became a part of the image unless later spotted out. In the case of unsuccessful negatives, the tough collodion image was scraped off, and the glass used again.

In spite of its difficulties, photographers were eager to use the new medium, and a great deal of work was done. One result was the generation of quantities of sharp, permanent (though fragile) negatives, and an increase in the production of prints. The resulting images were of far more interest to the public than calotypes, and far easier to reproduce than the

highly popular daguerreotype. Through the wet plate and its resulting prints—especially those on *albumen paper*, introduced at about the same time as the wet plate process itself—a large market developed for photographic prints, and the photographic industry such as we know it today, with its large production of prints from negatives, became established.

Prints from glass collodion negatives varied considerably in format and size. Probably the most frequently collected and published are the medium- to large-size prints of architecture, portraiture, and landscape, produced for wall or large album display, for which this form of photography is best known. Such prints can vary in size from the relatively modest, for example, 8 by 10 inches, to the considerably larger "mammoth plate" of about 18 by 22 inches used for the accomplished landscape, architectural, and sometimes still life work of the era. Some, such as the oversize images produced for sale to travelers in Rome, could reach several square feet and were produced through the combining of several negatives.

A number of smaller formats were available as well. The smallest commonly available print is the *carte-de-visite*, a diminutive image, usually a portrait, mounted on the stiff board of a visiting card, and of the same size—about 2½ by 4½ inches. Cartes-de-visite were introduced in the 1850s and were highly popular in the 1860s. Often the name and address of the photographer will be found printed on the photograph's paper mount—although due to the exigencies of the photography business, shifting partnerships, and employment, this information is not always accurate. Similar but somewhat larger is the *cabinet card*, roughly 4 by 6 inches, which was introduced in the 1860s and eventually in the 1870s replaced the carte-de-visite. These were large enough to be employed for landscapes and other scenes besides the portraits that were their primary use.

As with most of the smaller formats, cartes-de-visite by major photographers or of important subjects are sought after by collectors; the large number of pieces of only moderate or low interest are, however, far more common.

Also used primarily for portraiture were the tintype and ambrotype, two forms, usually small, of direct collodion images. The *tintype* was a collodion negative on metal, usually iron coated with dark lacquer or enamel. Because it was a negative, its image, like the daguerreotype or the photogenic drawing, was frequently reversed. The *ambrotype* was also developed directly on its support, but since in this case the support was glass, it could be turned over and presented— again with a dark backing—as a positive image. Both forms depended on the circumstance that, though relatively dark themselves, the collodion images appeared as positives when seen against a dark ground. Both types of image have off-white, pearly gray highlights. Tintypes, frequently primitive

Stereopticon viewer with stereograph inserted for viewing. Stereopticons, or stereoscopes, offered a three-dimensional photographic experience and were popular from the mid- to late nineteenth century.

or informal, are extremely tough and relatively difficult to damage, and were often presented in inexpensive paper or cardboard mounts. Ambrotypes, often considered a less expensive form of daguerreotype, were presented in enclosed cases similar to these latter fashionable objects, or in the ornate but inexpensive stamped metal frames popular at the time. While they are sometimes confused with daguerreotypes, close inspection will reveal from their translucence and lack of reflectivity that they are not on metal but glass. As with cartes-de-visites and other smaller formats, it is the unusual or important that is sought after by collectors. In the area of their subjects, each will have his or her own set of interests. In regard to the media themselves, as with most photographs, clarity and contrast are valued, along with artistic concerns such as overall composition and the quality of presentation of the subject represented.

Of a similar size was the popular *stereograph.* Stereos are simply small prints taken and mounted in pairs for viewing in three dimensions. In most cases a special camera was used with two lenses; a single plate received the double image, which was developed and mounted for viewing on a precut, printed cardboard mount. Some early stereo photographers produced the same effect by taking two views from two slightly different positions. Many stereos were printed from glass collodion negatives, but the stereo format both preceded and succeeded this particular photographic medium. (Some stereos were drawn by hand before the invention of photography.) The stereograph craze, which began in the 1850s, continued well into the twentieth century, an era in which the double images were produced as more modern forms of negatives and prints.

Other forms of the glass plate process less frequently known

or seen today were the popular lantern slide and the cliché-verre, which was employed almost exclusively by artists. The former was a glass transparency printed from a negative. When mounted with a piece of protective glass on its emulsion side, the *lantern slide* was easy to handle and suitable for projection in conjunction with parlor viewings, public lectures, or classes. Today, lantern slides, usually 3 by 3 inches, exist in considerable numbers in the few libraries and schools that recognized their value and did not dispose of them in the onrush of new media that followed their era—the late nineteenth and early twentieth centuries—principally, the celluloid color slide. *Cliché-verre,* on the other hand, was a process of which the public saw little. Using an opaque glass plate, artists would draw by scratching the surface with a sharp tool as they would in etching or engraving. Exposed over light-sensitive paper, the image, exactly as it had been drawn, was reproduced photographically. The cliché-verre was thus a photographically reproduced artist's drawing, a form whose results were a clearer, photographic version of those produced mechanically, though frequently with more subtle results, by the process of lithography. The form was popularized by Corot and others of the Barbizon school; cliché-verres are still available on the market. Another, rarer form of photograph of which collectors should be aware are the tiny prints sometimes incorporated into jewelry and other apparently nonphotographic objects. These aspects of Victoriana, like stereographs and cartes-de-visite, may constitute an area of collecting of their own.

A form of glass plate work deserving separate mention is the *combination print.* There are several ways to produce combination prints; their common link is the use of more than one negative in the production of a single image or print. The earliest form of combination printing was created to provide a back-

ground sky of clouds for landscape or architectural views at a time when photographic emulsions were not yet uniformly chromatically sensitive enough to record the subject of an image without overexposing the accompanying sky. For this purpose, the negative of the landscape or building image was printed with the overexposed sky area painted or masked out so as not to print. A second negative was then carefully placed over the partially exposed paper and printed, with the area corresponding to the landscape or building masked out. The result was a single image combining the desired components of two others. Careful registration, or physical correspondence of the two adjoining images, makes good combination prints difficult to detect—which of course is their intent. In the case of artistic photographers such as Rejlander and Robinson, the technique was intentionally used to assemble the components of quite complex images from a number of disparate negative sources. In other cases, as has been revealed in a well-known image of a French cloister by Édouard Baldus, the effect was so successfully hidden as to have gone undetected by most viewers for well over one hundred years.

Glass plate work comprises a vast variety of subjects, sizes, formats, and styles. To adequately distinguish and judge them, some knowledge of the photographer's working methods and intent are useful. With experience these can often be inferred from the work itself. A western landscape photograph by the American Carleton Watkins that is not exceptionally clear, clean, and spare, for example, would not be characteristic, while one of the same scene by his contemporary Eadweard Muybridge that is not correspondingly mystical and dramatic, with its clouds inserted by combination printing, would be equally uncommon.

The exceptional effort necessary to pursue wet plate work insured, up to a certain point, the relative quality of the prints

produced. This formula broke down with the growth of studios and agencies producing large bodies of work for an audience of travelers or enthusiasts whose interest was in their subjects alone and not in the techniques employed in producing them. The appearance of the preprepared commercial glass dry plate, in common use by the mid-1880s, produced a similar effect. The accessibility of the new process, which offered the benefits of a glass plate without the problems of wet collodion, provided an ease of use that seems to have caused the carefully constructed quality of photographic images to decline.

Excellent topographical images exist of subjects as distant as India and the Far East, or as near as the more familiar forests of Fontainebleau or streets of Paris and Rome, taken by photographers who saw themselves as artists as well as documentarians. As a practical matter, however, these are often found by potential collectors mixed with the lesser work of those who later photographed simply on assignment, often for no personal credit, even though the shared qualities of subject, negative, and print can make their images appear very much alike. In collecting, it is important to look at as many images firsthand as possible, and to examine photographic methods and techniques as well as the artistic nature of the image itself. The experience of viewing a large number of pictures will enable the neophyte, through practice, to approach the knowledge of the expert or serious amateur.

DEVELOPMENTS OF THE
LATE NINETEENTH CENTURY

Pigment Processes (1890–1910)

By about 1880, with the introduction of the dry plate, and a few years later the invention and wide distribution of the Kodak

and other portable cameras, and the development of celluloid roll film, the production of negatives became relatively routine. For the burgeoning amateur movement and for the serious photographer seeking expression, the forefront of development and change in photography shifted to the varying forms of the print. The two principal areas of expansion and change were in the increased use of pigment prints and the development of photomechanical processes.

In the case of *pigment prints,* the key principle was that colloidal substances such as gelatin and gum arabic, when sensitized with bichromates (today called dichromates) were hardened and became insoluble in water by exposure to light. In combination with the use of pigments for printing, this rendered them adaptable to photographic use. The various individual processes that stemmed from this differed largely in their specific chemistry and physical adaptations. What they shared was their potential for physical permanence and visual variety, being as chemically stable and chromatically varied as the pigments employed, and their susceptibility to hand manipulation, since the colloids used passed through stages in which they were malleable and soft.

Among the most commonly employed pigment processes were carbon, bromoil, and gum bichromate printing. The *carbon process,* one of the earlier forms, was patented in the mid-1850s by the prolific photographic innovator Alphonse Poitevin, though it only became practicable some ten years later with the improvements invented and marketed by Joseph Wilson Swan. In this complex process, a tissue coated with bichromated, carbon-pigmented gelatin is contact printed from a negative. While there is no apparent image, the gelatin exposed hardens from the presence of light. This hardened image is transferred to a second sheet and the unexposed gelatin removed through a process of pressing, peeling, and

washing. After further hardening by soaking in alum, the image, reversed in the transfer, is ready to print. A nonreversed image could be achieved by inverting the negative in the first step, or by an additional transfer at the end. While carbon prints were often the gray or black of the carbon frequently used, color could vary if other pigments were employed. As the negative was transferred directly, without manipulation, the final image usually resembled that of the original itself. Carbon prints were produced by many photographers. Their stability and resistance to fading is one clue to their identity, which because their color may vary is otherwise often difficult to distinguish from other processes.

In the *gum bichromate process,* introduced in 1894, a negative was contact printed on to paper prepared with pigmented, bichromated gum arabic. Following exposure, the gum not hardened by light was washed away. This process was hastened by additional action on the part of the printer with brush or water, offering considerable freedom to manipulate the image. The process could be repeated for additional colors or depth of pigment. Gum bichromate prints have the look of hand work favored by many turn-of-the-century photographers. A favorite color for the image was an ochre, or reddish, brown, resembling that of the artist's crayon. A characteristic user of the process is the French photographer Robert Demachy.

The *bromoil process,* though related to gum bichromate, and equally labor intensive, is a method of visual enrichment and enhancement that works not through the agency of light but on principles of chemistry and lithography. In this process, a gelatin silver bromide print is bleached in a bichromated solution including copper sulfate and potassium bromide, and fixed in hypo and water. While no visible image results, the gelatin of the print is hardened in proportion to the amount of

silver in the original image. The resulting sheet, or matrix, is soaked in order to dampen the gelatin. When oil-based ink is applied, it builds up the image in layers on the matrix; where damp gelatin remains, water repels the ink, as in lithography, leaving highlights. The finished print can be either dried or printed and reversed in a press. Full color prints can be achieved through the printing, and careful registration, of three negatives taken with three different color filters. The work of Heinrich Kühn provides a good example of successful bromoil printing.

Photomechanical Reproduction

In contrast to turn-of-the-century personal, expressive hand-printing techniques, photomechanical reproduction was a response to the need to distribute photographic images more widely. The most popular and well used forms, photolithography and photogravure, were based on the earlier artistic and reproductive processes implied in their names: lithography and the intaglio process of engraving.

In *photolithography* a lithographic stone (later a plate of metal or other material) is coated with sensitized, bichromated gelatin and exposed under a photographic negative. When washed with water, the unexposed and lesser exposed gelatin of the negative's highlights and shadows is dissolved, leaving a strong gelatin image hardened by light. Using the principle on which lithography is based, the stone or plate is then dampened; the greasy ink employed adheres to the gelatin but not to the dampened stone, producing the visible image that is then transferred to paper by printing. Lithography produces a very flat image that often retains the grain of the stone. A more complex and sophisticated version of the process, the *collotype*, produces an often sharper image and a specific, recognizable

pattern of reticulation in the ink, which can be identified on close inspection of the print. Photolithography was widely used; among the best-known collotypes are the motion studies of Eadweard Muybridge, published in the late 1880s. Like other successful processes, collotypes may be found adapted or improved under other names. In the case of the collotype, these include the Albertype and heliotype. For the collector, the most important matter is to recognize the method of printing; the specific name may, however, be helpful in identifying a particular artist or printer, or a useful hint as to the date of the print.

The process of *photogravure* was developed in Austria and first appeared in 1879. Like the hand processes above, it depends on the properties of bichromated gelatin. Unlike them, it uses a variant of the aquatint process employed in etching to produce a fine-grained, even-toned image with a high level of fidelity to the original from which it is taken. In photogravure, a tissue sensitized with bichromated gelatin is exposed under a transparency derived from the image to be reproduced. This wet tissue, its gelatin surface down, is pressed onto a copper plate which, as in aquatint, is dusted with an even coat of powdered resin. Using water, the tissue backing is then peeled away and the areas of unexposed, unhardened gelatin dissolved. Dipped in an acid bath, gelatin-protected areas are bitten more slowly, and unprotected areas more deeply, yielding a plate that will hold varying amounts of ink according to the lightness or darkness of the original image. The plate is then printed on paper in a press, giving the photogravure the plate mark characteristic of the intaglio process. Gravures are known for the evenness and subtlety of their tones. Perhaps the best known photogravures are those of the artists represented in Alfred Stieglitz's publication, *Camera Work*.

An additional photomechanical process of some importance

is the *Woodburytype*. While not widely encountered, its quality is high enough to attract the interest of collectors on its own merits. Woodburytype images were produced on a bichromated gelatin base on collodion which had been stripped away from a plate of glass. After exposure, the hardened gelatin was pressed into a sheet of soft lead, which created a mold. The mold in turn was filled with pigmented gelatin which when forced through a press was printed onto paper where it dried. On close inspection, Woodburytypes exhibit a characteristic dimensionality through which they can be identified. Woodburytypes are known for their even, continuous tones and for the warm red to brown hues in which they were usually printed, similar to those of albumen prints. They are often labeled with the name of the process. Some commonly found Woodburytypes are seen among the published works of the British photographer John Thomson and the portraits of artists produced for the nineteenth-century French series *Galerie Contemporaine*.

Platinum Prints

A late nineteenth-century process that also held importance into the twentieth century was that of platinum and palladium printing. This process, invented in Britain and commercially available to photographers in 1878, was not used for large-scale production, but as a means of producing elegant, delicate, individual prints of the highest aesthetic quality. Platinum is a non-silver process, and the prints produced resist fading to a high degree. To produce a *platinum print,* a negative was contact printed onto paper sensitized with a solution containing iron salts and platinum. The faint image produced was developed in a second solution that removed the iron salts and brought out an image in platinum where they had been.

Further washing in acids and water removed excess chemicals and staining. The delicacy and tonal range of platinum printing, and of the related Kallitype and Van Dyke processes, made them popular with photographers reacting to the expressive indulgences of the late nineteenth century. These artists, including several in the Stieglitz circle, used platinum—and later the similar but less expensive palladium method—to produce images of great visual sophistication. Though abandoned for some years due to their cost and changes in taste, platinum and palladium papers are again available and used today by artists seeking delicate tonal values or longevity in the life of their prints.

TWENTIETH-CENTURY DIRECTIONS

Probably the most revolutionary developments affecting photography after the turn of the century were not those based on processes drawn from an earlier time, but improvements that changed the practice of photography itself and those that expanded its role in publication. These include the introduction of popular and successful color processes, and improvements to papers and printing technologies that allowed the wide distribution of modern images.

Color became commercially available to photographers shortly after 1900 with the introduction by the Lumière brothers of the *autochrome*. These glass plates, whose registration of color depended on a layer of dyed vegetable starches and an emulsion of gelatin bromide, were viewed not as prints but by transmitted light—either by placing the plates in a small stand or by projection on a screen. While exquisite to look at and popular, especially with amateurs and for limited color work by professionals, autochromes were delicate objects with a rela-

tively narrow set of applications. It was not until the introduction of commercial color films by Kodak and Agfa in the mid-1930s and the expanded use of the three-color *carbro print*, a process related to carbon printing, that color became popular with the public and widely available to professionals. After this time, up to the present, a variety of color prints from commercially available films became increasingly common, eventually surpassing production in black and white. Such prints come in a wide variety of sizes and types ranging from the common small prints seen in family albums to images measured in square feet, meant to compete with painting. The differences between color processes, among them *chromogenic, dye transfer,* and *dye diffusion,* are subtle and complex and are probably best learned directly from experience.

Improvements in commercial printing allowed photographers to take advantage of the new medium of color. Reproduction of the fine color work that began to appear in the fields of fashion, food, cosmetics, and other aspects of advertising and publishing offered photographers a new set of specialties and careers. Wide circulation of sophisticated magazines, such as those produced by the publisher Condé Nast, provided a large and educated audience for photographs. Today, some of the images these readers saw, now in the form of originals from the files of artists, publishers, associates, or friends, find their way to the market. In other cases, the knowledge that a photographer had a career in publishing lends value and context to other work he or she may have produced.

Beyond this expansion of a relatively traditional role in illustration, those interested in the fine arts were expanding photography in less predictable ways. Experiments in photography that help define the field in the twentieth century include a wide variety of experiments with the use of point of view, motion, double exposure, and light, such as *solarization,*

photograms, collage, and the experiments with light abstractions produced by Alvin Langdon Coburn, Francis Brugière, Jaromir Funcke, Raoul Hausmann, and many others earlier in the century. In the postwar period this creative energy showed itself in the incorporation of photographs and photographic imagery in a wide range of painting, printmaking, and other media, of which perhaps the best known practitioners were Andy Warhol and Robert Rauschenberg, themselves each photographers of considerable merit. Today, the German artist Anselm Kiefer has begun to fill the same role.

Photography continues to move on. In recent years we have seen the introduction of two entirely new media: *holography* and *digital photography.* To what level such media, which extend the technological base of photographic imagery into entirely new realms, laser and digital technology, will achieve the collecting potential now enjoyed by other photographic work, is not yet known. Those with an interest should sit up and take notice: these new forms of the medium are already collected and shown.

SUGGESTED READING

Naomi Rosenblum's *World History of Photography* contains a three-part "Short Technical History" of photography. Gordon Baldwin's *Looking at Photographs* provides a quick and exceptionally clear reference to important terms and processes. Other books such as *Keepers of Light* and volumes produced by Kodak and Time-Life offer highly specific information on the technical side of photography.

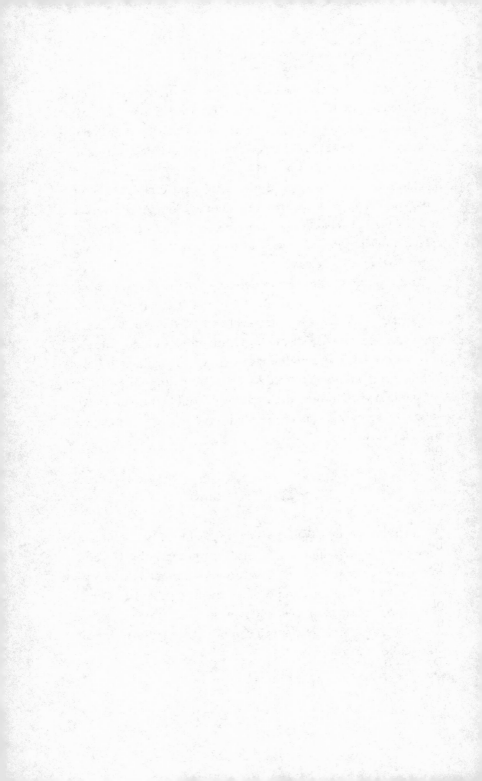

4
~

Types of Photographs

During the course of its history, photography has been used in many ways. In the first part of this chapter we will look at the different principal genres or types of photographs, approaching them by subject according to the intentions and uses envisioned for them by their photographers, or those who employed them. Such genres as landscape, portraiture, documentary, art photography, and illustrative work will be identified and described. In the second part of the chapter we will look briefly at the way photographs have been grouped in retrospect by curators, collectors, and scholars, and consider some of the larger, often external influences on photographers and their work, which cause it to be perceived as "schools" recognizable along lines of nationality, geography, materials, or style. This will provide the fundamentals of interpretation useful to a new collector approaching unfamiliar work, or help one more

experienced debating fine distinctions in identification, quality, or style.

The flexible, nonexclusive categories described here (some of which, to supply differences in perspective, appear in both parts of the chapter) are not the only ones into which photography might be divided, but they do seem to be among the most useful. Often a work will occupy more than one niche. A French landscape photograph in the Pictorialist style, for example, might be of interest for its national school, subject, or style; or a portrait of Lincoln for its aesthetic and technical, as well as its historical value. The overlapping of categories can thus be helpful in deducing the importance or significance of a particular work. Serious collectors often uncover categories of their own.

SUBJECTS AND GENRES

Still Life, Architecture

Architecture and still life were among photography's earliest subjects. To some extent they represented the solution to a practical problem. As lenses were not yet designed to direct light with great intensity on plates or negatives, and photographic emulsions were slow in registering what light did reach them, subjects that remained still were a necessity. At a time when exposures could range from minutes (portraits) to hours (landscape) to days (art in the dark halls of museums and churches), the immobility of architecture, or an arrangement of objects in a studio, had much to recommend it. Among the key images in photography that remind us of this is the first known permanent photographic image from a camera, Nièpce's view of rooftops taken from his window in southern France. The exposure lasted all day. Daguerre's early images

include still lifes taken in his studio and views of the immobile buildings of Paris. Talbot frequently used his house and its environs as a subject; architectural views make up a large portion of his work.

Of course, both architecture and still life have a long tradition in art before the arrival of photography. Although convenience may have been a determining factor for Nièpce in a time when photography did not even have a name, Daguerre, Talbot, and those who followed were well aware, even in the early days of the new medium, of the artistic tradition of the landscape and still life images they made. Besides the intimacy of recording one's own house, studio, or town, buildings and structures are part of images of travel, of urban photography, of monuments of various kinds, of feats of engineering. Large documentary projects, from the inception of photography to the present, have recorded architecture in specific sites, regions, or nations. Details of buildings are often the subject of artistic studies, and specific rooms may play a role in the recording of a group or family portrait. These are all subjects and categories that fit well within artistic tradition. Exemplary and well-known architectural work are the early photographs of Gothic cathedrals by Charles Nègre and Henri Le Secq, as well as the later views of Frederick Evans and Margaret Bourke-White.

Still life can be considered, for our purposes, a reduced form of architectural photography. Many of the artistic interests are the same. Photographers pursuing still life, like those associated with architecture, are fascinated by light, shadow, masses, and form. Still life tends to be produced under more controlled conditions, although not always. Some of the still lifes taken with the autochrome color process at the turn of the century, for example, were photographed outdoors in order to take advantage of natural surroundings and light. Still life subjects may be rather impersonal—a vase with some flowers—but just

as a picture of a building may not capture its personality, a still life like other pictures may instead tell us more about the photographer or the assignment that generated the work. The best still lifes, however, such as the large prints produced by Roger Fenton or the exquisite arrangements of flowers and leaves produced by the French photographers Braun and Aubry, evince a sense of involvement and interest: it is hard to ignore them, one is drawn in by their silent beauty and life-like delicacy.

Later, through its associations with Romanticism, still life played an important role as a subject in Pictorialism; through its implications of independence and detachment, the usefulness of still life was exploited in the exploration of abstraction and cubism as well. Today, interesting still life work continues to be done, both in black and white and in color, by photographers such as Jan Groover and Barbara Kasten seeking the distancing intellectual values pioneered through cubism and abstraction. Renderings of architecture may vary from the lively portrayals of twentieth-century edifices by Margaret Bourke-White, who is capable of bringing alive the Chrysler Building or a great dam, to the more melancholy images of ruins such as Kenilworth or Tintern Abbey favored by British Romantics in the earlier years of the medium. Also included would be the routine photographs taken for the records of cities and towns, or for other purposes, but these too can have their charm, and some have been taken by excellent photographers making a living to support their work in art.

Landscape

As better cameras were designed and photographic processes improved, photographers were enabled to work more successfully outdoors. The calotype era produced brilliant French

landscape work, such as that of Victor Regnault, Louis Robert, and others in the group at Sèvres, and scenes of the Pyrenees by a group of similarly inspired photographers, including John Stewart and Maxwell Lyte at Pau. Among British photographers the landscapes of Roger Fenton, like his images of architecture, still life, and war, are preeminent. Such early landscape work on paper appears with some regularity on the market. A smaller number of stunning daguerreotype views exist, such as the outstanding work of Alexander Clausel, but they are relatively rare, and because they must be viewed carefully and at close quarters, they represent a different, somewhat more precious and discreet experience from that of prints, which can be displayed and viewed with ease.

While there were important forays into landscape by the earliest photographers, the largest quantity of successful work occurred later in the development of the medium. With the introduction of the glass plate and albumen printing papers shortly after 1850, landscape became a more common subject among photographers and more widely popular with the public. By the 1860s and 1870s, through subjects including travel and topographical surveys, as well as landscape for its own sake, it had become a significant sector within the larger field of photography. The popularization of the stereoscope during this period added another element to the use of landscape as a subject. Stereo views had an aesthetic and an audience of their own. Successful stereographs produced a strong three-dimensional effect enjoyed as a novelty for family entertainment. Presaging the wide popularity of photographic media as a whole, production of the relatively inexpensive stereograph for parlor use far outstripped that of the larger and often more traditional individual prints for albums and display. Series of stereo views were developed and marketed by many firms based on such landscape-related subjects as travel, topography,

and the visual exploration of sites ranging from exceptional local curiosities to those of strange and exotic lands. The difficulty of assigning authorship and sources to some of these pieces, published by such firms as the Anthony Company in New York or the H. C. White Company of New England, both large suppliers of stereo views, is complicated by their habit of buying images of faraway places from companies who had acquired or commissioned the views directly, and presenting them on their own mounts.

Later in the nineteenth century, as photographers became more outspoken in the effort to seek recognition of photography as an art, landscape began to take on a more self-conscious resemblance to paintings and prints. The work of Peter Henry Emerson, though defined in terms of photography, has many of the recognizable elements of painting, such as careful juxtaposition of compositional elements, sophisticated use of light, and a Romantic view of rural life. His pictures of peasants at work in their fields are not only landscapes but images with an implied social content. Often the work of photographers in this vein is a response to other missions of photography at the time. The Romanticism represented by Emerson and his peers is certainly in part a reaction to the new kind of landscape produced by photographers pursuing topographic or commercial work, such as that commissioned by railroads and government surveys. These latter images, while often lyrical to the modern eye, are frequently devoid of the conventional trappings of culture sought by Emerson and others. Taken in out-of-the-way places, often revealing the results of commerce and industry, such views offered an interpretation of the land at odds with the ordered images to which artists were traditionally drawn. They were, however, pointing the way of the future. As photography proceeded into the twentieth century, the overtly artistic view of landscape became increasingly anachronistic and was even-

tually replaced—though in such a diverse field never replaced completely—by a more utilitarian approach in which the land and the camera themselves spoke more directly, and the photographer less.

Landscape, of course, plays a part in other genres as well. It has, as discussed above, a supporting role in documentary work. As such it describes the land surrounding projects such as railroads, dams, and new towns. It may provide the background for an architectural or historical view. In more recent years it often has a symbolic or metaphoric meaning: during the 1930s, views of American land by Arthur Rothstein, Ben Shahn, Walker Evans, Dorothea Lange, and others conveyed messages about politics, the economy, and the national character; today the landscapes of contemporary photographers such as John Pfahl, Len Jenshel, or Karen Halverson may employ pictorial conventions to imply a new message of irony or discomfort accentuated by its reference to earlier attitudes. In a general sense, all of these uses of landscape, in the end, refer back to our view of nature. The condition of the land— untamed, intruding, benign, or picturesque—determines in many cases the content of the image. Landscape images are ultimately about our relation to the land: that of the photographer, the viewer, or those who formed or controlled the land in the image itself.

A subject that joins still life, architecture, and landscape work is the photography of gardens. While much of this is done on commission for architects, owners, or magazines, some high-quality work has been done. Atget's views of French gardens and parks are an important and influential body of work. Images of such subjects may prove historically useful as records of taste, as well as being aesthetically pleasing on their own merits.

Another related area is that of cities and cityscape. These

may indeed often constitute landscapes, as well as portraying architecture, documentary, or other subject matter. Such views of cities themselves (apart from the images of action that play a role in the tradition of street photography), like Berenice Abbott's photographs of New York, for example, can frequently be appreciated for their formal and aesthetic qualities alone.

A separate branch of landscape is made up of views of water. Water may appear as part of an image, as in a pond in a landscape, or a view of a harbor or coast, as in the case of the British Pictorialist photographers Frank Meadow Sutcliffe or J. Craig Annan, or it may be the subject itself, as in the outstanding seascapes of Gustave Le Gray. In both cases, like land, it can be either a factual or symbolic element, and its success as a part of the image, along with the appropriateness of its related world of boats, docks, fishermen, or other appurtenances should be judged, for the purposes of photography, not by a factual fidelity but by the quality of its artistic portrayal in the picture.

Portraits and Poses

One of the most successful and sustained uses of photography has been in portraiture. In the daguerreotype era, portraiture proved to be the only widely viable commercial form of photography. Many pieces remain from that time. The best, like those of the Boston firm of Southworth and Hawes, capture the natural qualities of the sitter and a sense of spontaneity of expression or pose, which were difficult to obtain with long exposures and the heat generated by the light necessary to register a strong image. Additional qualities in portraiture are provided by the setting—the props, backdrops, and other

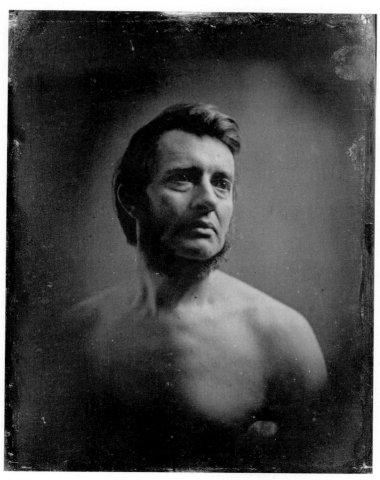

Josiah Johnson Hawes (American, 1808–1901),
Portrait of A. S. *Southworth,* half-plate daguerreotype,
C. 1848. COURTESY GEORGE EASTMAN HOUSE.

Albert Sands Southworth (American, 1811–1894) and
Josiah Johnson Hawes (American, 1808–1901), *Lockwood & Company*,
whole plate daguerreotype, 1852. BOSTON ATHENAEUM.

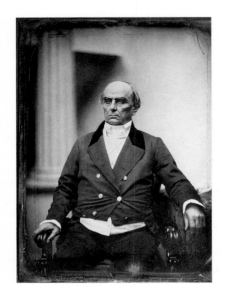

Albert Sands Southworth
(American, 1811–1894)
and Josiah Johnson Hawes
(American, 1808–1901),
Daniel Webster, whole plate
daguerreotype, 1851.

William Henry Fox Talbot (British, 1800–1877), *Carriages and Parisian Townhouses*, salt print from calotype negative, image: 16.8 × 17.3 cm, sheet: 19.0 × 23.0 cm, May 1843. THE J. PAUL GETTY MUSEUM, LOS ANGELES.

David Octavius Hill
(British, 1802–1870)
and Robert Adamson
(British, 1821–1848),
Portrait of Rev. Jones,
salted paper print,
c. 1845. COURTESY
GEORGE EASTMAN HOUSE.

Henri-Victor Regnault (French, 1810–1878), *Garden
Still Life with Vegetables*, salt print, 19.2 × 15.8 cm,
c. 1853. THE J. PAUL GETTY MUSEUM, LOS ANGELES.

Samuel Masury (American, 1848–1874), *On the Loring Estate,*
vintage salt print, c. 1856. HALLMARK PHOTOGRAPHIC
COLLECTION, HALLMARK CARDS, INC., KANSAS CITY, MISSOURI.

Édouard Baldus (French, born Prussia, 1813–1899), *Entrance to the Port of Boulogne*, salted paper print from paper negative, 1855. THE METROPOLITAN MUSEUM OF ART, LOUIS V. BELL FUND, 1992.

Carleton Watkins (American, 1829–1916), *Rail Road Bridge*, salt print, 32.2 × 40.8 cm, 1860. THE J. PAUL GETTY MUSEUM, LOS ANGELES.

Clementina, Lady Hawarden (British, 1822–1865), *Photographic Study*, albumen silver print from glass negative, early 1860s. GILMAN PAPER COMPANY COLLECTION.

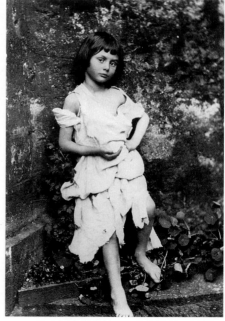

Lewis Carroll (Charles Lutwidge Dodgson) (British, 1832–1898), *Alice Liddell as "The Beggar Maid,"* albumen silver print from glass negative, c. 1859. GILMAN PAPER COMPANY COLLECTION.

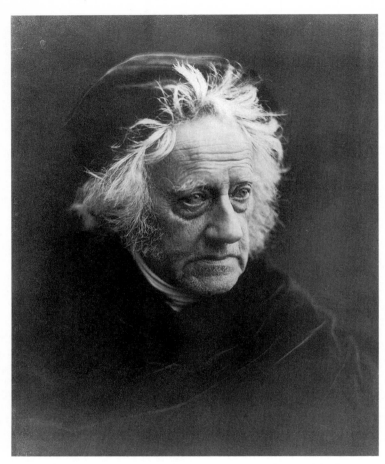

Julia Margaret Cameron (British, 1815–1879), *Sir John Herschel*, albumen
silver print from glass negative, 1867.

Roger Fenton (British, 1819–1869), *Still Life with Fruit*, albumen silver print from glass negative, 1860. GILMAN PAPER COMPANY COLLECTION.

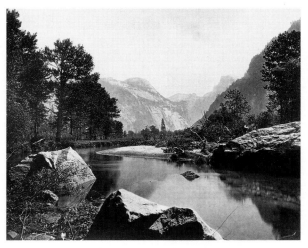

Eadweard Muybridge (American, born Britain, 1830–1904), *The Domes, Valley of the Yosemite*, albumen print from glass wet plate negative, c. 1872. COURTESY MICHAEL WILSON COLLECTION.

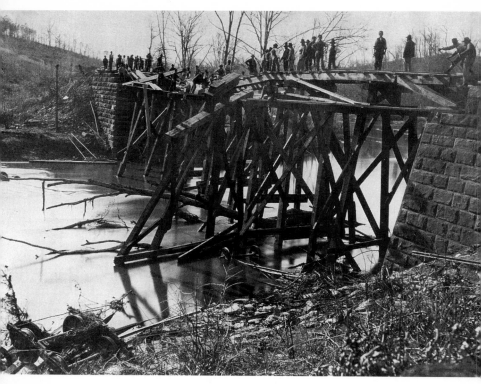

Andrew Joseph Russell (American, 1830–1902), *Bull Run Bridge Before Rebuilding*,
albumen print from glass wet plate negative, 1863. BOSTON ATHENAEUM.

André Adolph Eugène Disdéri (French, 1818–1890), *Princess Gabrielli*, uncut carte-de-visite, c. 1862. GERNSHEIM COLLECTION, HARRY RANSOM HUMANITIES RESEARCH CENTER, UNIVERSITY OF TEXAS AT AUSTIN.

Nadar (Gaspard Félix Tournachon) (French, 1820–1910), *Georges Sand*, Woodburytype, printed by Goupil et Cie. for the *Galerie Contemporaine* series, 1877. BOSTON ATHENAEUM.

Unknown photographer,
Miss Annie Oakley,
carte-de-visite, c. 1870.
THE J. PAUL GETTY MUSEUM,
LOS ANGELES.

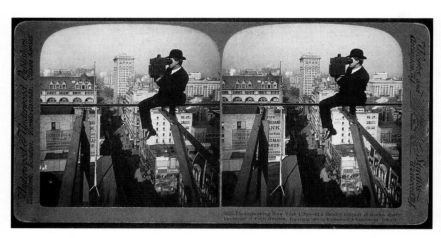

Underwood & Underwood (American firm, active in nineteenth and
twentieth centuries), *Photographing New York City—On a Slender Support
18 Stories above the Pavement of Fifth Avenue*, gelatin silver print on labeled
stereograph mount, 1905. THE J. PAUL GETTY MUSEUM, LOS ANGELES.

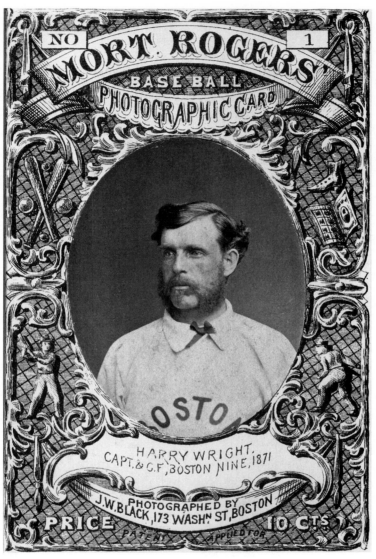

James Wallace Black (American, 1825–1896),
Morton Rogers Base Ball Photographic Card No. 1, Harry Wright,
albumen print on letterpress printed card, 1871. BOSTON ATHENAEUM.

Henry Peach Robinson (British, 1830–1901), *When the Day's Work Is Done*, albumen combination print from six negatives, 56.1 × 74.3 cm, 1877. THE J. PAUL GETTY MUSEUM, LOS ANGELES.

Henry Peach Robinson (British, 1830–1901), *Preliminary sketch for combination print*, pastel with inserted albumen print, collage on paper, c. 1860. GERNSHEIM COLLECTION, HARRY RANSOM HUMANITIES RESEARCH CENTER, UNIVERSITY OF TEXAS AT AUSTIN.

P. H. Emerson (British, born Cuba, 1856–1936), *Gathering Lilies*,
platinum print, 1886. COURTESY GEORGE EASTMAN HOUSE.

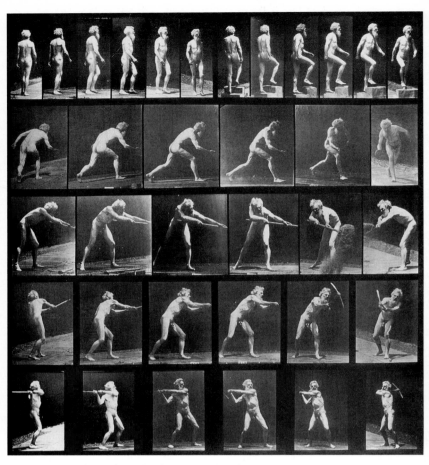

Eadweard Muybridge (American, born Britain, 1830–1904),
Animal Locomotion, Plate #521, photogravure, 1887. WILLIAMS COLLEGE
MUSEUM OF ART, GIFT OF THE COMMERCIAL MUSEUM, DEPARTMENT OF
COMMERCE, PHILADELPHIA, PENNSYLVANIA. PHOTOGRAPHY BY MICHAEL AGEE.

accoutrements supplied by photographers to their sitters. Finally portraits are affected by the case or frame, which may or may not be appropriate for the image enclosed. Some of the best calotype portraiture was done by the early Scotch photographers Hill and Adamson. Their classic images, whose use of strong light and shadow reflected the canons of the traditional portrait painting at which Hill had been trained, have stood up well, and are encountered regularly in the market today.

The glass plate era brought portraiture to a wider audience. A variety of formats from the tiny tintype, ambrotype, or carte-de-visite to larger formal portraits suitable for framing offered an almost infinite range of possibilities for reproducing the human visage. Among the most accomplished portraitists from this era were the redoubtable Nadar of Paris and Mathew Brady of Washington and New York. Many others flourished in the major cities of the world. There had always been a strong market for painted or sculpted images of public figures and those in the privileged classes. The particular advance wrought by photography, especially in this period, was the new availability of portraits to people of *all* kinds, in many places in which they had not been available before. For every famous sitter captured by Brady or Nadar, a hundred unknown were photographed in Nantes, Leeds, Hong Kong, or Grand Forks. Of the many photographs available in the bins of antique dealers or rural fairs, there are always some early studio portraits to be found. Beyond this first period of the medium, in the mid- to late nineteenth century, with the advent of the amateur and the growth of family photography through snapshots by the Kodak camera, and later in the mid-twentieth century by the Polaroid camera, the number of portraits increased exponentially.

Although the processes of photography became progres-

sively easier to manage, many of the factors tied to the skill and overall performance of the photographer remain a part of our judgment of portraits up to the present day. Fine work such as that of Gertrude Käsebier was done during the Pictorialist period, and in the succeeding turn to the straight and documentary styles by Lewis Hine and others. Later work of quality has been more sporadic. Although many photographers try their hand at portraiture, its human element makes it one of the most difficult to pursue with success. Whether some contemporary work, such as the innovative portraits and self-portraits of Chuck Close or Cindy Sherman, should be considered in the same light as that of earlier practitioners remains an open question. They are in any case highly accomplished and popular among collectors and institutions alike.

Indeed, portraits come in many forms. Whether as an individual or part of a group, a portrait may simply record an individual or it may interpret his or her appearance, stature, or role in society. Group photographs have dynamics of their own resembling those mentioned above, including spontaneity, humor, and occasionally an element of kitsch. In a general sense, portraits may range from the relative artlessness of a Civil War tintype or cabinet card and standard studio fare to the genre portraits of British photographer Julia Margaret Cameron of the same era (public figures or models arrayed as figures of mythology), to the famous "serial portraits" of Georgia O'Keeffe produced by Stieglitz, or of German citizens by August Sander—works produced in a number of differing images over a period of time. According to the flexibility of the interpretation applied, one may also speak of portraits of animals, buildings, and other subjects, the import of the word signifying that they have been singled out and treated as individuals, and a personality is conveyed by the image.

As with Julia Margaret Cameron, the attention given to individuals and groups may be adapted to some extent in genre work. The term *genre*, from the French, is used not only as a general term meaning a type or category of art, but refers specifically to scenes of everyday life and belief elevated to subject matter in the fine arts. It covers a wide range of imagery. In photography the constructed scenes of Rejlander and Robinson, and the portrayal of country life offered by Emerson come first to mind, as well as the quite different mythological scenes of Cameron. Still lifes may also be considered genre work if their emphasis is more on the domestic role of the objects pictured than on their purely abstract visual qualities. The inclusion of figures in genre work can bring it close to portraiture. Cameron's images of the painter G. F. Watts or the poet Alfred Tennyson as (sometimes rather unwilling) portrayals of figures of Roman or Greek mythology, or the works of Lewis Carroll picturing a posed Alice Liddell (the future Alice of Wonderland) and her peers, are as much of interest because of their dramatis personae as for their ostensible cultural or artistic themes. As portraits, however, the price of their anecdotal interest is often the sacrifice of the gravity of the best studio work. A well-known exception is Cameron's series of portraits of John Herschel, some of which, highly personal and interpretative, reveal through art a great deal about the character of the sitter.

Genre work was pursued in professional studios as well. Many pictures exist, made for reproduction and sale, of themes such as peasant or city life, the pleasures and travails of travel, and other common experiences of everyday life. In some cases studios had sets or backdrops (as at parks, fairs, and some studios today) where sitters could place themselves so as to easily create such images. Such pictures may be of interest; the over-

all artfulness of presentation and execution, as well as the demeanor of the sitters and nature of the setting are some of the factors to be considered in evaluating pictures of this kind.

Another approach to the human presence in photography is the nude. Nudes have been present throughout the history of photography, from the daguerreotype onward. As a subject, the nude has tended to appeal either to artists exploring it from the traditional, disinterested point of view of form or to those exploiting it for its illicit content. A third category, sometimes spanning the two, are "studies" done for the use of artists, in some cases photographic versions of the *academies*, or academic nudes, produced by students of art during their training in studios or schools, in other cases something a bit more explicit. The nudes of Eugène Durieu and J. V. de Villeneuve, known to have been used by artists, are much sought after; those of Alphonse Mucha, best known for his posters and graphic work, bear a clear relation to his oeuvre in these media and are of considerable interest. Of the more illicit type, the range of pieces spans the gamut from the usually small images of the early photographic formats to later twentieth-century prints, in black and white or color, for calendars and publications. Like other specialized areas, the nude has its own set of conventions. The standards of quality for the nude in photography much resemble those in the other fields of art: composition, sophistication of execution or technique, and the commanding presence of the image's subject. As with other major genres and periods, more information on the nude as a subject will be found in most general histories of photography and art.

Documentary, Reportage

Photography has a long tradition as a recorder of fact. Among the first known uses of photography in reporting occurred as

early as 1853, in George Barnard's daguerreotype view of burn-
ing mills in Oswego, New York, taken almost a decade before
his highly accomplished Civil War work. But reporting is only
one role played by photography in this area—the most consis-
tent is the documentation of architecture and cities. Often it is
undertaken in support of historical record or research, as with
the early French architectural documentary project Missions
Heliographique (1851), or the later work in Paris from Marville
to Atget, and in New York by Atget's acolyte Berenice Abbott.
In Glasgow (1868), Thomas Annan documented the old quar-
ters or *closes* of his native city. The Depression produced the
large documentary projects of the American government
through which Arthur Rothstein, Walker Evans, and other
American photographers became known. Corporations
employed photographers to document aspects of their physical
plants, as with a famous panorama of the Krupp factories in
Germany or the superb work of Charles Sheeler for the Ford
Motor Company in Detroit.

A more active sector of documentary work is the reporting
of conflicts and wars. First employed for the purpose in the
1850s, photography was used during this period to record
direct views of devastation in India, China, and the Crimea, as
well as creating in the 1860s the immense catalog of pho-
tographs developed through the efforts of Mathew Brady,
Alexander Gardner, and others during the American Civil War.
With better equipment and faster films, photographers of the
twentieth century made their careers and names in conflicts
such as the Spanish Civil War and the Second World War,
which were covered far more than earlier wars in the burgeon-
ing new photographic newsmagazines of the day. Among the
best known or most important of such images are Félice Beato's
stark views of the devastation after battles in India and China
in the late 1850s and early 1860s and Roger Fenton's views of

the Crimea of only a few years before. In France, Le Gray's views of army maneuvers, though aesthetically highly sophisticated, constitute a form of reportage; photographic records of the dead from the Paris Commune are a grisly reminder of one of the medium's common uses in postmortem portraiture (pictures from this conflict were also controversial for their use in identifying possible traitors). Later, one thinks of Robert Capa's well-known image of a soldier in the act of falling during the civil war in Spain, and Capa's blurred views of the D-day landing in France, as well as the equally iconic but more traditionally composed view taken by Joe Rosenthal of the raising of the flag on Iwo Jima. Such images have truly changed our relation to history, events, and news. Contemporary coverage, such as that of modern wars in Asia and Africa, and records of internal conflicts such as the civil rights and earlier union movements in the United States play an important role in our understanding of, and response to, these events, and may be of interest to collectors on this account.

The nature and quality of visual reporting changed with advances in the technology and materials not only of photography but of printing. While Brady's photographs were printed in quantity and widely known, the only feasible vehicle for such images were individual albums and mounted prints. Thus copies of Barnard's *Photographic Views of Sherman's Campaign* and Gardner's *Sketchbook*, probably the best albums of the Civil War, both relatively expensive and sumptuous, as well as similarly produced volumes featuring the Crystal Palace, royal visit festivals, and other public events, were by modern standards extremely limited in number. Photographic images were copied by hand for wider publication as wood engravings, but their limited visual impact in this medium bore no comparison to the original. With the development of inexpensive printing and papers, the first reproductions of photo-

graphs, not of the highest quality, began to appear in newspapers and magazines. Later improvements led to photographically based publications, such as the eponymously named rotogravure, and later the newsmagazines on coated stock, as we know them today. With each step, the impact of photography increased. From the point of view of collecting, it is helpful to recognize the inverse relationship between this growing sophistication among photographers and publishers and the decreasing technical difficulty of capturing significant action. Early on in photography, we are impressed as action begins to make its way into documentary images of different kinds, from wars to street life; later, with action relatively easy to capture and considerably more familiar in photography, we begin to look for more recondite formulas: where a photographer is; how he or she got there; how the action portrayed has been visualized and its significance conveyed.

Another key area in the use of documentary photography has been work done in support of the social sciences and reform. These related areas are often represented by the work of Jacob Riis and Lewis Hine, but other such photographers worked throughout the world. It is not uncommon to find in archives, libraries, and other institutions images of migration, labor, housing, and other issues of concern worldwide to critics of industrialization and laissez-faire social policy. In the social sciences, photography has been used almost since its inception to document ethnographic and cultural aspects of travel and study: voluminous records of housing, costume, and folkways fill the vaults of museums of natural history, anthropology, and science. Some of these works are of interest, others are either of academic interest only, or may be marred by their role in study—frequently with writing or markings directly on the print.

On the supply side of society's fears and concerns, photog-

raphy plays an important role in the documenting and report-
ing of crime. Mug shots were an early use of the medium. The
career of the American photographer Weegee (Arthur Fellig)
during the 1930s and 1940s was based on his reporting of dis-
asters and crimes—a specialty that proved extremely effective
among readers of the popular press.

The documentary role of photography is extremely impor-
tant. Its appeal to collectors will probably depend on the sub-
ject of a particular work or series of works, as well as on the
relative ability of the photographers under consideration.
Searching out photographs of your local, regional, family or
historical affiliations, or other specific interests, is a good way
to begin to form a sense of the variety and attraction of this
genre.

Photography as an Art

Much has already been said in earlier chapters about the qual-
ity of photography during particular eras, and the various
movements directed toward its use as an art. As with others,
this is not an exclusive category. With earlier outlines in mind,
some overall observations can be summarized and expanded
to the advantage of potential collectors. In all eras the aesthetic
qualities of prints and of pieces in non-paper media are a para-
mount consideration, even though they are defined in different
eras and in different media in different ways. Thus, a crystal
clear daguerreotype is the one usually preferred, while in the
calotype of the same era, a soft, gently mottled effect, more
resembling the chiaroscuro found in painting, is sought. Later
in the century, as photographic materials and technique
change, the clarity and stillness that connoisseurs find desir-
able qualities of excellent glass plate work came to be replaced

by an unthinking, mechanistic tone indicative of the more conventional form of production from which this work now emerged. With experience it is possible to see this. It helps explain the return to more overtly artistic values of turn-of-the-century photographers, in which work in new materials, sometimes even depicting a new set of subjects, is suddenly presented in a way that harks back to the old and comforting styles of an earlier time. In each era, certain cameras, papers, subjects, and styles are likely to be preferred, or vehemently eschewed, by particular groups of photographers. In some cases, such as that of the writings of P. H. Emerson, John Ruskin, or H. P. Robinson, the role of the critic or intellectually engaged photographer is important in setting an artistic agenda. It is useful for a potential collector to begin to familiarize him- or herself with these benchmarks; with time they become familiar and can be read with some ease in the pictures themselves.

In the twentieth century, aesthetics and style have been affected by changes in social and historical conditions (industrialization, war, the Depression, the tense calm of the postwar period), by the growth and success of the publishing industry, by the new mobility that produced large bodies of work by individual photographers covering immense geographical areas and a wide variety of subjects (the travels of Edward Weston and Robert Frank; the interpretation of monuments and parks by Lee Friedlander). Photographers have always moved about with alarming ease—the careers of Félice Beato and Eadweard Muybridge, long before travel was as easy as it is today, covered several continents—but they do so now at a rate nearly impossible to trace. The career of a photographer for a newsmagazine, or for the stock agencies that commission and distribute professional work for publication, produce col-

lections of negatives and prints numbering in the tens of thousands. Photographers' movements change with each assignment. The awkward personal encounters and facial expressions sought by Garry Winogrand in the middle of this century were the bane of his forebears; clearly the standards by which his work should be judged differ from those employed before.

As photography came to be used with increasing regularity and variety in the fine arts, holding its own with painting, printmaking, and other traditional media, often playing a role within them as well, a new set of choices engulfed it. Some contemporary work imitates the old; some is created in media that only a few years ago did not even exist; some do both. Some, put together with Scotch tape, torn, or distorted, appears to be intentionally distressed, while other work labors to preserve traditional physical values of craftsmanship. Similarly, an image we may recognize, either individually or as an example of a type, from a newspaper or magazine we bought for a dollar, may be glimpsed as part of a painting or print displayed at a museum or gallery. It helps to know that some of these unsettling conventions originated with the antiestablishment activities of Picasso and Braque, the popularizers of collage, but at a certain point such mixtures of media, images, and techniques begin to take on a life of their own. What we think of them today is a combination of advice from the well informed and an educated opinion of our own. In photography as in other media, knowing the context and specific histories of artists and art is an asset collectors will find irreplaceable.

Not all of the many schools, approaches, and artists can be covered here. It is safe to say, however, that the artistic quality of work is measured in three distinct ways. One is as an exemplar of the particular medium, school, and time of which it is a part: Is a photograph an early piece that shows the develop-

ment of a particular approach, or a later one that reveals it at its peak or in decline? The second concerns the craft itself: given the idea or subject behind a photograph how well did the artist do at revealing his or her vision? Is craft applied in the service of art? The third element is that of invention. In all the arts the moment at which a new idea appears is the focus of intense scrutiny. Photographs that announce the arrival of new forms of vision or expression, or the appearance of a new artistic personality, are highly valued. Did Man Ray invent the photogram? Did he "reinvent" it? Had he ever seen earlier works such as those of Talbot or Anna Atkins, or was he just capitalizing on darkroom knowledge known to all photographers? To what extent does the vision of Berenice Abbott reflect that of her mentor Eugène Atget; at what point in her career does she reach a plateau in which she establishes a vision of her own? Was Aaron Siskind influenced by abstract expressionism, or was he one of its sources? Is the postmodernist Sherrie Levine a great innovator, or a thief? Your answer to these questions, and others like them, will determine how you value certain pieces, careers, and even entire periods of photographic art. When several or all of these factors work together you are likely to have a work of extraordinary strength.

Illustration, Advertising, Fashion

In the twentieth century, the role of photography in the allied fields of illustration, fashion, design, and other media-oriented areas of publishing increased dramatically. Although a model for their use existed in the images hand-tipped into the commercial albums which are one of the rare and unique acquired tastes of nineteenth-century photography, expanded use was not possible until the arrival of improved techniques of print-

ing. Careers in photography in these areas proved stepping-stones for photographers into galleries, collections, and commissions, and constant public exposure provided a spur to more sophisticated work. Careers of such masters as Edward Steichen, Baron De Meyer, Anton Bruehl, and Paul Outerbridge would have been impossible without the photographic commissions emanating from the increased business in fashion and manufacture characteristic of the first half of the twentieth century. The important photographer and teacher Clarence White emphasized to his students early in the century that art and commerce might profitably be joined through photography; many, like Bruehl and Outerbridge, took his advice.

Today, photography in advertising is highly sophisticated. In many ways it has responded—through size, style, color, and dramatic content—to the competition of the moving image of film and television. The pieces most sought by collectors tend to be from the classic period earlier in the century when commercial photography was developing into a field of its own, and drew to it photographers whose early careers linked them firmly to the arts—although the best contemporary artists in the field now command high prices as well. New definitions of what art is, its tenuous borders with commerce, and the varied practices of photographers, often moving between the separate areas of commerce and art with ease, make such distinctions increasingly difficult to assert. Some recent work, like that of Richard Prince, uses images from advertising and media; others, like that of Barbara Kruger, recreates images and styles derived from it. The interest in earlier images is to some extent an effort to avoid these distinctions and leave them for a later time in which they will be more clearly defined. Those willing to give the field some time and thought, however, may well be able to identify the classics of the future long before others have made up their minds.

In commercial photography, as in other areas, collectors need to consider the inherent tensions that guide the production of new works. Here they could be capsulized as a spectrum with the disinterested qualities of design at one end, and the exigencies of marketing on the other. Works that solve the practical challenge of interesting clients through an imaginative use of the abstract principles of design, or which simply stand out, visually, on their own, would seem reasonable objects for collection or study.

Industry, Science

From the beginning, photography has had a close relation to industry and science. Its inventors and their forebears saw photography as the child, and possible future handmaid, of science and commerce. In this they were largely correct. One of the first uses of the new medium was in the recording of fine and minute objects and patterns difficult and sometimes even impossible to be accurately copied by hand. Through this method, complex patterns in leaves and shells were studied and classified with greater ease. At the instigation of Talbot, intricate hieroglyphs were recorded for study. Using the telescope and the microscope, images of natural forms that few had ever seen were produced and reproduced by camera. Through use of the lantern slide such images provided the grist of lectures, and, through publication, illustrations for books setting out new areas of science. Such uses only increased with time.

In a period virtually mad with building, science, and machinery, photography has played a number of roles. In the area of building, the construction of ships, buildings, bridges, railroads, factories, and canals were recorded. Sometimes these images served as records of progress; at other times they were

used to interest investors; in still others they might appear as items in the published news, or as images framed on an office wall. At the close of a project the camera was frequently used to document the proceedings—the launch of a ship, the opening of a canal or bridge, or any number of other momentous events. In the development of machinery and industrial processes, photographs often played the role of record keeper, or that of confirming through visual proof the results claimed by scientists or inventors. An interesting example is the album made by the American photographer A. J. Russell as part of his work with Civil War railroads. The pages of the album document experimental bridges, trusses, pontoons, and other mechanical inventions and adaptations developed by the Union army, including ways of foiling the similar advances by the South. Such photographs are frequently valuable for their rarity more than their aesthetic value. They are also of use in tracing little known byways in the career of an artist, telling us not only for example, where he or she was at a certain time but who commissioned certain projects and might therefore be considered an influence—or occasionally an obstruction—to the aims of the artist and his career.

Important work of this kind is seen in conjunction with the development of other major industries: oil, shipping, construction, agriculture—the list is virtually endless. Where there is nothing dramatic to be photographed, often images of other sorts are recorded. Every corporation has standard shots of office work, employees, products, and other elements of business life. Photographs are used to introduce new products or to advertise them. Photographs of the testing of products constitute a borderline between industry, science, and art. The visual interest of industrial and scientific images varies tremendously. Countless pictures exist of gear wheels, trucks, and ships. The

rules of thumb that apply to them are of the same sort as those for other photographs: strength of the image, quality of the print, inventiveness in portraying the subject. Not all photographers of industrial subjects were of the stature of a Sheeler, Weston, Bourke-White, or a Strand, all of whom worked in this genre. Still, the sheer number of photographs made argues for the discovery of new talent as yet unseen by the public. What interests one collector may be that rejected by another.

Among the great pictures from the sphere of industry and science are the railroad albums, such as those by Baldus in France and Russell in the United States, and images of Britain's two Crystal Palaces, such as those taken by P. H. Delamotte. The building of the Eiffel Tower fascinated photographers, as did the earlier construction of the Paris Opera, producing images such as those by the firm of Durandelle, which appear frequently on the market. The documentation by the British photographer Robert Howlett of the building of the immense steamship *Great Eastern* provided not only powerful images of industrial progress but personalized it through the inclusion of its designer, the great engineer Isambard Kingdom Brunel. Brunel's bridges and other similar projects appear in diverse images of the time. The early American suspension bridge at Niagara Falls was a frequent subject for photographers, as were the many industrial, world, and regional fairs that have been public preoccupations for the last century and a half. In the twentieth century, science photography is often identified with Harold Edgerton, the MIT scientist whose work with stroboscopic lighting produced the well-known images of bullets and other fast-moving objects captured in a fraction of a second. Many other interesting photographers and works in this genre exist as well, among them the early images of snowflakes captured by Bentley, a series on physics by Berenice Abbott, and

over the course of photography, many extraordinary images of stars.

SCHOOLS

Apart from their intent, photographs are often grouped in other ways by curators, collectors, and scholars to account for some of the larger, often external influences on photographers and their work. At times this will take the form of schools, recognizable along lines of nationality or geography; in other cases the organizing factor may be such considerations as materials or style. Overall groupings are of interest to collectors as they help place photographic work in context, and supply useful information of considerable help in interpretation.

British and French

In Britain and France, where photography was first invented and used, early traditions developed that, aside from their own inherent importance, had an effect on later work and often set a standard for others to follow. Until the late nineteenth century, when photography became considerably more international and styles flowed more easily between artists far separated by geography, British photography was characterized by a strong amateur tradition, pursued by families and circles of acquaintances and friends. This was in part because of limiting patents taken out by William Henry Fox Talbot, which slowed the spread of early professional work. It was also a result of the relative homogeneity of Britain's society, through which the spread of photography was often linked by personal friendships and mutual professional interests. While it would

be far too broad an interpretation to say that all British photography shared this quality, it is true nonetheless that images of the Stratford area associated with Shakespeare or the Lake region of Wordsworth, for example, although valid as pure landscape or, in the case of ruined abbeys or towns, as architecture, have a familial quality of their own, akin to the more intimate views of country houses and family scenes to which they are related. The British also produced a high level of professional, topographical, and expeditionary work, published by some of the largest printing concerns of the time, such as those of Valentine and Frith. This widely published work, however, shares much with that of other large-scale photographic firms of the time and is often not necessarily British but more international in character.

In France, photography was launched from the beginning as a public concern. It was quickly adopted for use in large-scale projects. Some of the best early work has a subtext of national, regional, or historic pride that gives it a character of its own. The presence of a considerable amount of visible ancient history on French soil, in the form of structures dating from Roman times onward, also lends a specific cultural character to much of this work, linking it in subject, though not in emotional tone, to work done in Italy at the same time. As might be expected from its artistic tradition, French work is often extremely aesthetically sensitive. Daguerreotypes, calotypes, and glass plate work; portraits, landscapes, architecture, still lifes, and nudes, to mention a variety of media and genres, are all likely to be recognizable as the work of particular French artists. At times the work of small groups, such as the exceptional group of photographers centered at Sèvres, may display a strong identity based on shared media, subject matter, or approach. In some cases the work of an individual, such as

Nadar, and his evident ease with his subjects, may be so strik-
ing and original as to be virtually inimitable. France has also
become home to a number of expatriates, from the American
Man Ray to the Hungarians André Kertész and Brassaï (Gyula
Halász). The effect on their work of France itself, and especially
of Paris with its many photographers and well-known subjects,
constitutes a distinct aspect of French influence.

American

The American experience has a particular relation to photogra-
phy. The continent was explored as the camera was becoming
known. The art of photography grew up with the country or, to
put it another way, the continent became a testing ground for
the development of a new medium. Thus, from 1839 to the late
nineteenth century, and to some extent beyond, changes in the
medium of photography—from the daguerreotype, through
the many forms of glass plate work, to the rather uninteresting
stabilization of photography that came with its mechanization
and commercialization, and the later response through a return
to art—correspond to changes in American life. Early portrai-
ture records scions of New England, Philadelphia, and New
York, builders of ships and towns; slightly later the same
medium records easterners and their ships in the new towns
they built in California. The glass plate records the succeeding
Civil War, the railroads built to reach California by land, and
the landscape in between. The dry plate shows us new cities,
styles of architecture and life, and forms of travel. The art
movement in photography reveals America's growing interna-
tional importance in the realm of culture and art. The impor-
tant documentary work accompanying the Depression records
an entire chapter of national life. The growth of photography in

publishing is tied to new twentieth-century directions in commerce and photographic media, including television, film, and now the computer, through which our lives have been changed to a degree hitherto unknown. (The one exception in this photographic procession is the calotype, which was virtually unknown in America.) All of this gives American imagery and photographers a unique role in the development of the medium, linking Gold Rush daguerreotypes, for example, to later "western" films and imagery of films to that of advertising in a way that has influenced photography and its imagery throughout the world. For Americans, expeditionary photography took place in their own land, and their exploration of a new medium became in a sense one of the largest self-portraits of all time.

German, Italian, Russian

German chemists and lensmakers are responsible for important technical innovations in photography, and German photographers often figure among the most important of their movement and time. Alfred Stieglitz, a key figure in American and world photography, was prompted toward his interest in the field through a course in photochemistry taught by Hermann Vogel, the German photographer, critic, and chemist whose influence on the field includes key improvements to the chromatic range of photographic emulsions. In all important eras, as defined by medium or style, Germans have been represented by high-quality work. Among the best-known photographers are the daguerreotypist Freiderich von Martens, who worked extensively in Paris; the important documentarian August Sander, whose multi-image serial portrait of Germans remains a social as well as artistic achievement; and the

Pictorialists Hugo Henneberg and Hans Watzek, who with their Austrian peer Hienrich Kühn formed the influential early twentieth-century group dubbed the Trifolium. More recently Germany has produced the modernists Berndt and Hilla Becher, whose grids of architectural images have become a fixture of the world of galleries, museums, and auction sales. Germans were also early curators and photohistorians, as they were early art historians; German museums and galleries have often led the way internationally, especially at the turn of the century, with important photo exhibitions, including those held regularly at Berlin, Hamburg, and Munich.

Italy is known both for its photographers and its subjects, as well as for the work of expatriates produced there. In Venice, Carlo Ponti and Carlo Naya produced the views best known and most widely disseminated; the Alinari photographic empire, focusing especially on architecture and art, was centered at Florence, which still houses both the firm and a related museum. Many photographers settled or worked in Rome, among the best of them the British-born photographers Robert Macpherson, James Anderson, and the French calotypist Frédéric Flachéron and his circle. Of all global topographical subjects, Rome (like its many related ruins throughout Europe and the Mediterranean) was perhaps the largest single source of images and prints, notable for their varied range of sizes and formats.

In Russia during the nineteenth century French cultural traditions, including those of photography, were strong. Studio and royal portraiture reflects this. Outside the cities, a considerable amount of ethnographic work was also done: images of Russian "types," highly varied due to the extensive range of Russian cultures and lands, are a fixture of photographic production there. Artistically, the most important contribution of

Russian photographers has been the work of its avant-garde artists of the post-revolutionary period early in the century, including artists such as Alexander Rodchenko and El Lissitzky, whose ties with others in central and eastern Europe were strong, and whose work in photography was allied to the interest in design, film, and the graphic arts prevalent at the time. From the period of the Second World War, battlefront correspondents who distinguished themselves, such as Dmitri Baldermants, have only recently come to the attention of photography collectors in the West, after years of neglect due to the stresses of the Cold War.

Expeditionary

Photographic categories often supersede boundaries of nationality and geography. Almost from the beginning, photography was employed to document and present expanding empires, travel, construction, and exploration. The work done in this genre often shares a common purpose—recording the exotic, novel, or monumental: Despite the disparate aesthetics, techniques, and individual styles employed, a commonality of style unites it as well, derived from shared conventions and equipment of the time. Among the first views published from the camera were the hand-inscribed plates from daguerreotypes included in N. M. P. Lerebours' *Excursions Daguerriennes,* which recorded images of exotic travel and architecture. European photographers soon expanded on this with extensive tours to the Middle East, such as those by Teynard, Salzmann, and others, whose images included subjects of architectural, historical, religious, and literary interest. In America, expeditionary photographers such as O'Sullivan, Jackson, and Bell worked on government surveys focusing on geology, economic develop-

ment, ethnology, and other aspects of settlement. In Asia and the Pacific, photographers such as Félice Beato and Baron von Stillfried recorded ancient cultures along with the new activities of trade with the West. In Central America, Desiré Charnay of France portrayed sites of an ancient culture that few had ever seen. With such diverse subject matter, it is useful to know that photographs of many different kinds, taken for a variety of purposes—from government work to the needs of corporations, or to supply the scholar—can be grouped under the rubric of expeditionary work, a category that can often lend meaning or perspective to pictures whose similarities may be otherwise difficult to discern.

Documentary, Archival, Scientific

The objective use of photography to record facts includes a vast array of subjects and images, from the socially interested work of documentarians to the highly specialized work of photomicroscopy in botany or physics. Through photography aspects of history or its documents are recorded; new records are made and older ones copied; collections of objects or art are photographed; cities in transition are pictured for those who will see the changes, but not what preceded them. Many commercial uses of photography, from real estate to portraiture, also produce banks of images. Such accumulations of documentation often result in archives—bodies of work, or collections. Some may become available to collectors, others—for reasons of their inherent qualities or inaccessibility—may not. Here, canons of taste are a determining factor: to some viewers, a picture of the stars taken through a telescope, or an image of molecules or cells from an electron microscope, or of a new piece of industrial equipment may be visually stimulating or exciting,

while to others it may not. To some, an image of a deserted battlefield of the Civil War may provoke melancholy with overtones of the sublime or the picturesque; to others it may prove disturbing, or not be moving at all. The extent to which such areas of factual subject matter translate into art of interest to collectors will depend in part on the nature of the work, in part on the fascination of the individual collector with the subject or with the artist. There are no hard and fast rules. It is important to remember, though, that photographs taken by artists with aesthetic intent differ in nature and tradition from those we later judge to be of interest *despite* their origins in the realm of science and fact. Both are worthy of our attention; their nature as objects, however, in regard to art, is considerably different.

FURTHER CONSIDERATIONS

Applications by Artists

In contrast to the factual uses of the medium of photography stands the wide variety of its overtly artistic uses, of which we have spoken in discussions of style, conventions, and techniques. As a distinct part of this use, collectors should also be aware of the less visible role of photography as supportive servant of the arts. In this guise, work was produced in a variety of genres and media—among them still lifes, portrait or life studies, landscapes, and nudes whose sole purpose was as artistic guides or aids in other work. In some instances they may reveal themselves by being printed in the cyanotype or another lesser medium, but this is not always the case. In evaluating a still life, for example, it is useful to know whether it was intended as a finished work, or as a model for a painting; was it part of a series, or a single work to which particular care

was devoted? Was it created for sale, or for personal use? Such considerations, often gleaned from reading and experience, or from contextual information such as written notes on the piece or its mount, will probably not change your judgment of the work itself but may well provide useful shades of meaning in comparing it to others of its kind, or help to distinguish it from other works by the same artist.

Publication and Critical Response

Because of its relative accessibility, novelty, and popularity, in conjunction with improvements in communication and travel, photography was among the first in the arts to become international. An example is the complex set of movements in the late nineteenth and early twentieth century when photography turned away from the sphere of the working professional and gained cachet from its association with the fine arts. In evaluating photography from this period, roughly the 1880s to the 1920s, it is useful to know the intent and methods of the photographer, as well as his or her professional and personal affiliations. Frequently the inclusion or exclusion of work from particular shows or publications can determine its status in the field (apart from its inherent value, which is for the collector to determine). Such factors, including how a piece may have been reviewed in connection with such benchmark events—especially publications and exhibitions—often hinge on distinctions (or purported distinctions) of school, affiliation, and professional or amateur status that meant much to photographers and critics of the day. Knowledge of such considerations, present during all periods of the medium, and often best traced in the books and journals of the time, can help collectors unravel some of the complexities of photographic and critical practice

and distinguish truly important work from lesser pieces of similar appearance or style.

Informal and Nonprofessional Use

Although not perceiving themselves as photographers in any formal sense, nonprofessional users of the medium, in the context of the family, travel, or scenes of local or regional interest, may occasionally produce work of note. Not only is some of this work of interest as a kind of naïve art in the relatively new medium of photography, but on occasion subjects of other significance may appear. Changing fortunes and careers may turn the young lawyer in a local portrait, newspaper picture, or banquet memento into a senator or magnate. The offhand, quirky amateur image of an event, or an image indicative of an era, may turn out to be preferable to the staid picture produced by a professional of the time. Probably the best-known photographer in this vein is Jacques Lartigue who took many of his most popular images as a child in France. Other sought-after images are the more personal, innovative pictures taken by painters such as Degas and Vuillard, experimenting with photography out of curiosity, and perhaps with an eye to learning something visually new as well. Collectors will find numerous albums or collections from family attics, studios, or the files of organizations. Evaluating whether they are of more than merely passing interest is frequently a test of reason over sentiment.

Unknown Photographers

Finally, because of the history of its development and, in the absence of sufficient identifying evidence, the anonymity of its product, the category of photography where the specific artist

is unknown (or in some cases suspected but unproven) is especially large. There is much good work in this category. In some cases, entire careers or bodies of work are known, but the artist unnamed; in other cases individual pieces of merit appear with no clear way of linking them to the work of a particular photographer. Confidence is needed to judge these photographs on the basis of style, subject, and condition. Fortunately, however, this is often enough. An illuminating parallel may be a case in American painting, in which three bodies of regional work were associated with three separate but unknown artists. All were considered of high quality, but collecting was inhibited by evidence that separated them on the basis of differing geographical areas. Continued research revealed that these three New England "limners" were in fact the same itinerant artist. The increased knowledge of his work provided a new foundation for evaluation, both in artistic and financial terms. Those who had collected the work on the basis of its merits alone were vindicated. Similar examples exist in photography. Single works become separated from the bulk of an oeuvre and may be rediscovered out of context; entire bodies of work, or single works, may be unidentifiable, but nonetheless remain of great aesthetic interest. As a collector, such judgments can be the key to acquiring excellent, undervalued work.

In sum, to recognize the types of photographs, schools, and other categories of photography considered here, it is important to acquire as much knowledge as possible. It should be used with flexibility in order to apply the various aspects of photographer and work to the understanding of the particular object under consideration. The best collectors, curators, and scholars know a great deal about specific historical eras and the personal histories, professional habits, and careers of photographers. Often particular works of art are known in all their

details: subject, photographer, printer, provenance, and condition, although, only in rare cases does this information approach the level seen in the study of paintings, drawings, and sculpture, whose longer and more complex histories are routinely traced. In viewing a photograph, one must ask: What is the subject? How is it handled—the intention behind it, the style in which it was done? If you are looking at pictures of the American Southwest, how do the pueblos seen in the work of Adam Clark Vroman differ from those pictured by John Hillers, or Timothy O'Sullivan? Time period, materials, intent, and differences in artistic temperament would play a role. In evaluating a work from the Civil War, should it be seen as a landscape or a social document? If inspecting a European view taken at a steep angle from a tower, is it indicative of the excitement of the first such views, or does it exemplify a later adaptation of the style, and thus perhaps become of less interest? Such questions are what draw people to collecting. In the next chapter we will look at how to get started on the resulting quest.

SUGGESTED READING

The various types of photographs are set out in most general histories, including the thoroughly illustrated volumes that have appeared since 1989, such as *On the Art of Fixing a Shadow,* published by the Art Institute of Chicago and the National Gallery of Art. Commentary on photography and its interpretation is frequently the territory of essayists, commentators, critics, and scholars; among those who have made key contributions are Roland Barthes and Walter Benjamin, and more recently A. D. Coleman, Susan Sontag, John Szarkowski, and Alan Trachtenberg. More radical contemporary reevaluations

of such earlier theories have been undertaken by writers such as Allan Sekula and Abigail Solomon-Godeau. In recent decades the literature of photography has expanded substantially; plentiful monographs, museum catalogs, and critical literature offer devoted collectors much to read.

5

UNDERSTANDING PHOTOGRAPHS
AND THEIR VALUE

Having looked at the history of photography, some of its techniques, and how it is perceived by those who pursue it as enthusiasts and professionals, one of the most immediate concerns of the potential collector—how to evaluate photographs—can now be addressed. A combination of knowledge and instinct, this is by nature a complex matter. While you may enjoy the enthusiasm and mystery of the chase for objects of art, the triumph of discovery will be of little avail unless you know what it is you have found. The objective of this discussion will therefore be to offer some ways of understanding photographs, so that the opportunity they afford (or lack thereof) can be evaluated and judged.

Interpreting the value of photographs involves a number of factors. In brief it may be said that one must arrive at a judgment that reflects the *significance* of the object and places it in the context of the current market. That is to say, determine in

light of one's knowledge what a photograph might *mean* in the larger setting of the medium and its history, and then, equally important from the point of view of collecting and cost, what— for whatever reason—it might mean to others. In a sense one is balancing origin and effect: Is a particular Atget image to be considered as the study it was taken to be or the masterpiece it may now be considered to be? Is a certain early Watkins survey print primarily a landscape or a document? Is a photograph generated by the government's Farm Security Administration project a personal statement by the artist, disinterested social commentary, or pure propaganda—or some combination of the three? Is it an original vintage print? Is the image of aesthetic interest for its own sake? Does it presage a stylistic change, or result from one earlier? Is it characteristic or unique? In order to make informed choices about these and other factors affecting value, some general guidelines are needed. Those described in this chapter are helpful to know in the pursuit of pictures. Although by nature interdependent, for clarity they have been grouped as visual, physical, historical, and judgmental.

VISUAL QUALITIES

Image

Probably the first reaction any collector has to a photograph is to its image. Image refers to the overall visual impression of a work, including its subject, its composition, and graphic strength. (In technical usage the term image can have other, additional meanings.) Some experience with photographs and the market usually leads to the conclusion that certain images and image characteristics contribute to the value of a work. Exactly why this should be the case is easy to see, but difficult

to explain. Works of art have a presence, a complex personality made up of some of the elements we have discussed. One first grasps this in the image, the overall "face" of the picture. In light of further intellectual, historical, or physical discoveries about the picture, such as its style, medium, condition, or provenance, the validity of the image and its first impression may either be further supported or fail to be sustained. The image itself, however, remains as the most salient aspect of a picture. Some areas of judgment for an image are its graphic strength (contrast, boldness of visual elements), subject (a horse, a statue, a building, a nude), and composition (construction and juxtaposition of visual elements). Beyond these, a viewer begins to look at the more subtle aspects of the artist's visual presentation, such as the specific relationships between the elements represented, their possible symbolism, and the delicacies of shadow and light. While these are parts of the image, they constitute a second, less readily perceived aspect of the picture to which one is reacting. Some images may be entirely, or almost entirely, composed of such "secondary" aspects—shadow, fragmentary action, nuance. This does not mean that they are less important than their bolder counterparts, simply that the approach of the photographer differs from that of a more openly declarative style. Such pieces need to be looked at differently, as their images have been constructed—at least outwardly—in a more subtle way.

The success of an image depends on a hierarchy of elements. These may differ from style to style, era to era, artist to artist. Often, in the market, priority is given to known subjects and places. A landscape of a mountain valley, however engaging, may take second place to one specifically of Yosemite, a favored haunt of photographers for over one hundred years. A portrait of an aging French author of little note, however flawless, may lose by default to one of Baudelaire or Zola. The same

is true of types of subject or genres; these may each have small followings of their own, but general approbation in the market may be withheld. On the other hand, such rules cannot be applied without exception. The serious collector of French photography may well opt for the better portrait of a lesser-known subject, and the student of landscape be less intrigued by yet another view of Yosemite than by a finer image of a less familiar locale.

The image is the best-known aspect of a work. Given the number of different images of subjects that may be similar, it is helpful to develop a specific memory of particular benchmark images: Stieglitz's Flatiron Building versus the equally well-known one by Steichen; the genre scenes of Clarence White; the austere facades of Walker Evans; the classic interpretations of Yosemite by Watkins, Muybridge, and later Ansel Adams. Such images can serve as comparisons and standards for others, as well as helping to identify and evaluate lesser known pictures by the same artists.

Style

The second response you are likely to experience in looking at a photograph is that it represents a certain period, style, or school. Documentary work will stand out from a Pictorialist or "artistic" approach; work dealing with changes of the twentieth century will differ from earlier work in geographical exploration; and contemporary action work will differ from early pieces in which action is rare. Often these are cues that will be followed by others: the interest of certain artists and periods in aspects of light and form, in specific subjects, in recognizable styles. Take care to distinguish some of the many crosscurrents that appear as a part of the evolution of styles: imitation is considered a form of flattery. What you value will depend to some

Unidentified photographer, *Two women and two men at a gate, shadow of the photographer*, gelatin silver print, Snapshot #2, c. 1889. COURTESY GEORGE EASTMAN HOUSE.

Clarence H. White
(American, 1871–1925),
The Orchard, vintage
platinum print, 1902.
HALLMARK PHOTOGRAPHIC
COLLECTION, HALLMARK
CARDS, INC., KANSAS CITY,
MISSOURI.

Frederick Evans (British, 1853–1943),
In the Attics: *Kelmscott Manor*, platinum print, 1896. GIFT OF
MRS. RALPH W. MORRIS, COURTESY MUSEUM OF FINE ARTS, BOSTON.

Dwight A. Davis (American, 1852–1943), A *Pool in the Woods*,
vintage gum platinum print, c. 1918. HALLMARK PHOTOGRAPHIC
COLLECTION, HALLMARK CARDS, INC., KANSAS CITY, MISSOURI.

Berenice Abbott
(American, 1898–1991),
New York at Night,
silver print, 1933.
COURTESY MUSEUM
OF FINE ARTS, BOSTON.

Alvin Langdon Coburn
(American, 1882–1966),
Vortograph, vintage gelatin
silver print, 1917.
HALLMARK PHOTOGRAPHIC
COLLECTION, HALLMARK
CARDS, INC., KANSAS CITY,
MISSOURI.

Lazlo Moholy-Nagy (American, born Hungary, 1895–1946),
Untitled, Stockholm, 1930, vintage gelatin silver print.

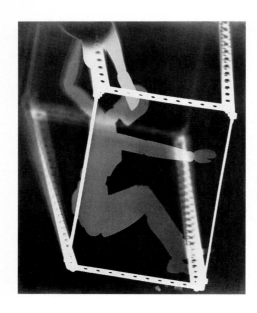

Man Ray (Emmanuel Radnitsky) (American, active France, 1890–1976), *Mannequin with Metal Box*, gelatin silver rayograph, 29.2 × 23.4 cm, 1925. THE J. PAUL GETTY MUSEUM, LOS ANGELES.

May Ray (Emmanuel Radnitsky) (American, active France, 1890–1976), *Pablo Picasso*, gelatin silver print, 29.4 × 22.9 cm, 1932. THE J. PAUL GETTY MUSEUM, LOS ANGELES.

Aenne Biermann
(German, 1898–1933),
Rubber Tree, gelatin
silver print, c. 1927.
GILMAN PAPER COMPANY
COLLECTION.

Edward Weston (American, 1886–1958), *Sand Dunes,
Oceano, California*, silver print, 1936. SOPHIE M. FRIEDMAN
FUND, COURTESY MUSEUM OF FINE ARTS, BOSTON.

Paul Outerbridge
(American, 1896–1958),
Collar, advertisement for
George Ide Co., platinum
print, 1922. THE MUSEUM
OF FINE ARTS, HOUSTON.
© COURTESY G. RAY HAWKINS
GALLERY, SANTA MONICA.

Anton Bruehl (American,
born Australia, 1900–1982),
Top Hats, advertisement
for Weber and Heilbroner,
gelatin silver print, 1929.
COVILLE PHOTOGRAPHIC ART
FOUNDATION.

Maurice Bratter (American, 1905–1986), *George Washington Bridge*,
vintage gelatin silver print, c. 1930. HALLMARK PHOTOGRAPHIC
COLLECTION, HALLMARK CARDS, INC., KANSAS CITY, MISSOURI.

Dorothea Lange (American, 1895–1965), *Mother and Child*, silver print,
early 1930s. SOPHIE M. FRIEDMAN FUND, COURTESY MUSEUM OF FINE ARTS, BOSTON

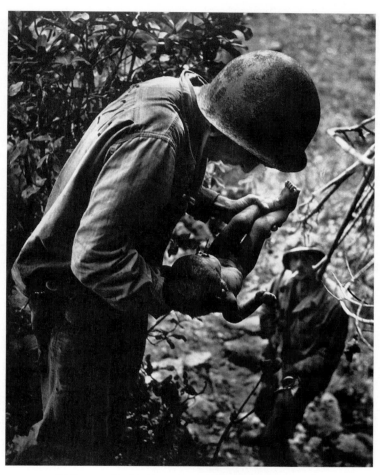

W. Eugene Smith (American, 1918–1978), *Dying Baby
Found by an American Soldier in Saipan*, gelatin silver print,
22.1 × 17.0 cm, 1944. THE J. PAUL GETTY MUSEUM, LOS ANGELES.

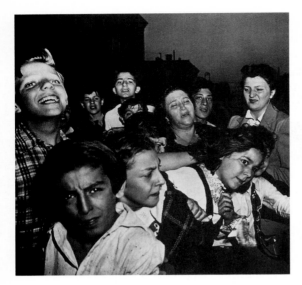

Weegee (Arthur Fellig)
(American, born
Poland, 1899–1968),
Their First Murder,
gelatin silver print,
before 1945,
25.7 × 27.9 cm.

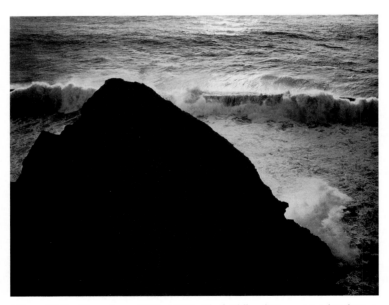

Minor White (American, 1908–1976), *Black Cliff and Waves, Matchstick Cove,*
California, 1947.

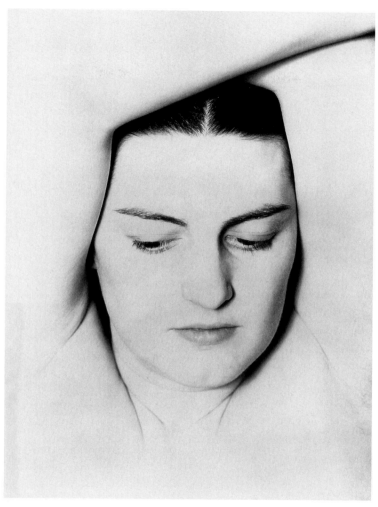

Harry Callahan (American, 1902–), *Eleanor*, gelatin silver print,
22.9 × 16.6 cm, 1947. THE J. PAUL GETTY MUSEUM, LOS ANGELES.

Garry Winogrand (American, 1928–1984),
American Legion Convention, Dallas, Texas, gelatin silver print, 1964.
ESTATE OF GARRY WINOGRAND, COURTESY FRAENKEL GALLERY, SAN FRANCISCO.

Lee Friedlander (American, 1934–), *Lee Avenue,* gelatin
silver print, 1970. COURTESY FRAENKEL GALLERY, SAN FRANCISCO.

Robert Adams (American, 1937–), *Lakewood, Colorado*, gelatin silver print, 1974. COURTESY FRAENKEL GALLERY, SAN FRANCISCO.

Nicholas Nixon (American, 1947–), *Heather Brown, Mimi Brown, Bebe Brown Nixon, Laurie Brown, Harwichport, MA*, 1978. COURTESY FRAENKEL GALLERY, SAN FRANCISCO.

Joe Deal
(American, 1947–),
Colton, California, 1978
(from the portfolio
"The Fault Zone"),
1978. COURTESY OF
THE PHOTOGRAPHER.

Bernd and Hilla Becher
(German, born 1931
and 1934), *Framework
Houses*, four-panel
gelatin-silver print
typology, 1996.
COURTESY FRAENKEL
GALLERY, SAN FRANCISCO,
AND SONNABEND
GALLERY, NEW YORK.

extent on what you want to collect. Style, intent, and the era in which a picture was taken provide general guidelines. Within these broad categories, other determinations related to value can be made: is the picture a representative example? is it a later imitation? is it a rare survival? For example, if a De Meyer floral still life from the era of *Camera Work* is admired purely for its delicacy and the treatment of its subject, the work of one of his followers might be purchased for a considerably smaller investment. If collecting De Meyer himself, however, the work of a student or admirer will not do, although it may be of interest as a study piece for comparison.

The relative importance and interest of certain styles, schools, and the work of particular eras wax and wane. Thus, it is difficult, possibly even misleading, simply to designate certain photographs among them as being of more or less value than others. The advantage of bringing as great a breadth of knowledge and discrimination as possible to decisions of value is to be able to judge the varied works one is likely to encounter in the widest possible context. A few years ago daguerreotypes were available for a fraction of what they now cost; few had the vision or developed taste to buy them. Photography itself was until recently largely a stepchild in the family of arts; without the serious changes in taste that have occurred over the last few years, the discussions we have been having here would not be needed. By developing objective standards, and sharpening your taste on the best work, bodies of photography of styles, eras, and schools yet undiscovered can be identified, found, and ultimately collected.

Artist

Related to the general question of period and style is the more specific and extremely important question of the artist of a

work or series of works. Frequently this is the most significant piece of information about a work of art. Sometimes, even in the form of a theory, to know or postulate the identity of the artist can supply the critical ingredient to its meaning—and thus to its status in the field and value on the market.

For many experts in the field, the lives of artists, their careers, their aesthetic affinities, and often their specific works are well-known territory. The career of the artist provides a framework for the placing of individual works; similarly, the artist's place in the hierarchy of his or her school, medium, and time offer a quick thumbnail method of assessing by comparison the oeuvre as a whole. Thus, one may be faced with a decision such as this: Is a certain British photographer affordable because his position is underappreciated and his work thus of greater value than is generally perceived, or is it relatively less popular for reasons that could be supported by comparisons with other similar work, leaving its current value unchanged, or even diminished? For information or opinion on this sort of issue consult the work of critics or scholars who have written on the subject. If the work of the photographer is on sale, or recently on the market, the gallery, dealer, or auction house involved can be approached. If the work, or something similar is on view, or available at a print room or museum nearby, taking a look at it could help to make a decision about the artist's work.

In pursuing these avenues the potential collector needs to keep in mind an important consideration: the source of the information about photographers and their work and the comparative value of the information itself. Those who are involved in the selling of art often have a great deal of practical information about it; those who study it frequently have a complementary sense of its history and meaning. The necessary

knowledge usually lies somewhere in between. To learn more about a photographer you might consult a monograph on the artist and his or her work, or perhaps on the period of which he or she is a part. A catalog of a relevant museum exhibition could be sought out, or an auction or dealer catalog in which the work or something similar is included. (Chapter 6 and the suggested readings and sources, deal with this topic.) All of these are valid sources of information, but they are frequently of different weight in making a decision. A scholar who has spent five or more years, say, researching a certain period of an artist's life can be expected to know more about the works it generated than someone whose familiarity with it is only of the short duration necessary to put together a catalog for a single show or auction. On the other hand, market or street knowledge of an artist's work, developed by those who have frequently confronted it is, in comparison, likely to be more savvy and up to date. Of course, some scholars and practitioners combine both; the point is to be able to distinguish the difference. A scholar may be able to point out the finest works of a particular artist, but this will do you no good if they never come to the market. Conversely, a dealer of photographs may have word of mouth and other direct information about an artist, but such information would be difficult to substantiate in a way that would affect the value of the work in question.

Artists and their careers constitute a tricky area for beginning collectors. In all good faith (and sometimes not) artists may be either lionized or consigned to the lower ranks on the basis of critical attitudes, market opportunities, and the whim of fashion. The only real insurance against such changing winds of taste is to buy works you like and understand, and to continually strive to develop the historical and aesthetic background necessary to support your views.

Knowledge of the artist can be of use in two other specific ways. The outlines of an artist's career and oeuvre serve to guide collectors to bodies of work within them—the results of commissions, portrait sittings, and travel, for example, and to establish a sense of what might be expected at certain periods of the artist's life. Second, through increased knowledge of an artist's work, a collector begins to know the character of the artist. Thus, a work can be judged for its characteristic qualities (or not), a matter that affects both its value and meaning. Together these enable a collector to put his or her pursuit of objects at the service of the larger goal of supporting the vision of the artist.

PHYSICAL CONSIDERATIONS

Media

Photographers are printmakers and artists. A number of the elements influencing the value of their work concern the specific way in which it was done. A negative can be produced on a variety of translucent materials through the use of one of many different kinds of cameras, or in some cases without a camera at all. A print may be unique, like a daguerreotype or more recently the Polaroid, or it may (more likely) be a multiple taken from a negative. If so, it may be printed on one of any number of papers or other surfaces. The printing may be done by one of dozens of techniques, whose varieties are virtually infinite. Photographs may be original vintage prints produced by the artist soon after the image was recorded, or they may have been printed later; they may also be prints from the same negative produced by an assistant or professional printer. They may be proof prints produced for the information of the

artist, or exhibition prints done with a demanding public and critics in mind. They may be individual works, or part of a series or edition. Something looking very much like the original may occasionally be found to be a carefully made reproduction—in some cases authorized, in others not.

Such issues of identification are not unique to photography. They represent an aspect of the graphic arts, and in some sense all the arts. In photography they are, however, especially complex. To separate the different types of prints a working knowledge of materials and methods is needed. References for such research are readily available; some are listed in Resources, Chapter 9. In general, the specifics of the methods and materials a photographer uses follow the style and intent of his or her work. Documentary or news photographers do not use expensive and time-consuming methods of printing on a daily basis, it runs contrary to the purpose of the field in which they are engaged. Similarly, turn-of-the-century photographers who valued the role of photography as an art can be expected to have produced work of exacting quality and enduring materials that is in keeping with their vision of themselves.

In looking at photographs of various kinds, some determination of the type of print or paper, and the kind of camera used, are useful components of a decision about a work. First, they can reflect attitudes of the artist; second, they can be a key to identifying artists, periods, and other information useful in determining value; third, they can offer a quick indication of inappropriate information that might prevent mistaking a particular photograph for something it is not. (The presence of dots, for example, seen through a magnifying glass, always indicates the halftone process used in mechanical reproduction. An assessment of the origins and purpose of the work should reveal the appropriateness of this medium.) Although to some

extent value is associated with particular media (platinum prints are more expensive to make and often reflect—or are meant to suggest—a refined sensibility; calotype prints by some photographers are often preferred to their later albumen work), there are no broad guidelines. Such judgments tend to inhere in specific cases and to involve other considerations, such as artist and era. For most collectors, involvement in the field and familiarity with a range of works builds confidence considerably in assessing the relative importance of media.

Condition

However a photograph was made, and whoever made it, it comes to the attention of a collector in a specific condition. It may be pristine in appearance, matted, and framed; it may be relatively tattered and unmounted. Such matters of condition are relevant to value, but may be of more or less importance according to their relation to other circumstances. As with other aspects of determining value, it is necessary to establish how a particular photograph arrived at its current condition, determine the significance of the condition in relation to the value of the piece itself, and finally relate the condition to the ultimate physical stability of the piece.

Frequently the physical history of a work of photography will not be known. Occasionally pieces are traceable through families or institutions from which they have come, or exhibitions in which they have been shown; but most often this is not the case. Condition is thus largely determined by examination of the object itself. In most instances, the condition of an object will reveal itself through some common signs: stains, tears, folds, fading. Interpretation of these in relation to value proceeds on an object-by-object basis.

TEARS AND OTHER DAMAGE. Tears at the edge of a picture may not themselves constitute important damage, but it takes only a slight mistaken movement of the hand to extend tears into the image. Thus, a picture that is solid and safe to handle has some clear advantages over one that is not. Certain physical problems with photographs pose irreversible damage that can be masked but never truly repaired: scratches, folds, or missing areas, and glue, tape, or ink on the image are all fairly serious matters of condition, even on a print that otherwise looks very good. The same is true of the presence of earlier repairs, which while apparently improving the value of a work, and in some cases necessary to preserve it, also serve to mask a problem. On the other hand, pictures that to a beginner might appear damaged may in fact with care be restored to a virtually pristine condition. An example is unmounted albumen prints, which over time tend to naturally roll themselves into tight little tubes. Though alarming to the beginner, there is actually nothing wrong with them. Care must be exercised in opening them to a flattened state in which they can be viewed and mounted, something which should probably be done by a trained conservator.

FADING AND STAINING. Among the most common forms of condition problems are staining and fading. The sources for these can differ. Until recently, much of the cardboard and paper used to mount photographs had a relatively high acid content (it was not of "archival" quality). The result has been that many photographs—and prints and drawings as well—in otherwise good condition become stained simply from their backing, mounts, and mats, and sometimes from the glue used to attach them. The traditional use of wood as a framing, backing, and storage material has yielded the same results. From

mats, one sees a yellow stain ("mat burn") around the edge of the print; from wood backing, often the grain pattern of the wood itself works its way into the paper on which the photograph is printed or mounted. According to the prominence and extent of such stains, value may be affected. Another kind of staining results from incomplete washing during the process of development. These often irregular stains may have the uneven, sometimes puddling lines of the liquid in which they were bathed, or the residue of chemicals may contribute to the discoloration of certain specific parts of the print. Stains can often be reduced, though rarely completely eliminated, and if present should certainly be considered in a general assessment of a picture.

Fading can occur with all silver-based materials, as well as other pigments. Faded photographs are almost always of lesser value. The condition generally comes from exposure to light, either from improper storage or extended display in an area receiving too much natural light. In some cases, photographs fade simply from chemical processes not resolved in development. In all these circumstances the age of the piece should be considered: a piece that has faded only slightly in a hundred years is not likely to suddenly do so at an accelerated rate; on the other hand, such pieces must be taken in the condition in which they are found: faded photographs do not regenerate their original darkness and density, and a piece that has begun fading needs especially good storage and care. Pieces that have been stored in albums or mounted in books may exhibit edge fading; the importance of this in regard to value depends on a number of factors, including the extent of the fading into the center of the image, and comparison with the condition of other existing images. Some bodies of work do not exist without edge fading (the work of Hill and Adamson almost always

exhibits it); in other cases, such as large land-, city-, or sea-scapes whose full extent is part of their enjoyment, value may be adversely affected if other less faded prints are available. In the case of recent works, particularly color, fading that has occurred already in the short life of a piece should be taken seriously indeed.

SILVERING, SPOTTING, RETOUCHING. Further common problems of condition are silvering, a form of aging that reveals the silver in a photographic image; and spotting or retouching, the hand-applied paint or ink used by photographers or their assistants to mask blemishes. The latter sometimes appears later in the life of a print if its original range of color begins to change. Silvering is often tolerated, but does indicate a deterioration of the image. The marks of retouching and spotting can be minimized through conservation but often represent imperfections in the original image that can never be reversed.

RESTORATION AND CONSERVATION. Some other, often more sensitive condition issues result from intentional improvements to photographs, made specifically to affect their attractiveness or value. In relation to collecting, these are for the most part the concern of the high end of the market in which there is a larger range of values and more potential profit in the sale of an image, but it is good to know about them in any case. Photographs may be restored in various ways. In most cases, responsible minor restorations by a conservator, such as the careful replacement of a lost corner or the filling of a tear, will be tolerated in the interest of preserving the image or print as a whole, though they do affect value. Other kinds of restoration are not so easily tolerated and often devalue the work in direct relation to how "successful" the repairs appear to be. Forms of

restoration such as rephotographing and hand painting—
sometimes done together, do recreate an image less troubling to
look at. Their legitimate use, however, is limited to reviving
family heirlooms and pieces of personal significance. Recently
this has been accomplished with even greater accuracy by use
of the computer. Unfortunately, these forms of reviving injured
photographs take us farther from the original work, which is
the objective of the collector. A more problematic, and less fre-
quently encountered, form of restoration is called intensifica-
tion. This is a process of redevelopment in which a faded image
is strengthened chemically. It is done usually for images of con-
siderable value. Its presence should be considered in cases of
rare images in unexpectedly good condition.

In conservation the watchword is reversibility. Historians,
curators, and collectors now have hundreds of years of experi-
ence with what was once euphemistically called "restoration."
Today, due to the experimental quality and unpredictable
chemical nature of some treatments, most experts believe that
any work done to a photograph, or other work of art, should be
able to be undone, if necessary. In noting repairs done to a
work under consideration, be sure to ascertain that this is the
case.

Presentation

Finally, a word should be said about the presentation of pic-
tures, and who in fact presents them. Pictures will come to the
attention of collectors in a wide range of condition and presen-
tation. The two should not be confused. Presentation is a form
of marketing as well as, possibly, of a reflection of the delicate
condition of an object; it bears no direct relation to value. That
a photograph is well matted or framed, or both, means only

that: it has been matted or framed. The important matter of condition considered here refers only to the object itself. Mats and frames contribute to preserving the condition of a work of art. Their own materials and construction are relevant; they may also on occasion accentuate some of the aesthetic qualities of the object; but they do not speak for the condition of the object itself. In considering an important photograph, most serious collectors will unframe it to inspect it carefully. The temptation to purchase a piece because of the power of its over-all presence, including mount, mat, and frame, is usually to be resisted. In the scheme of collecting, mats and frames are relatively inexpensive; it is the object itself on which a collector should focus.

By the same token, straightforward dealers or gallery owners, while putting their best foot forward by carefully matting and framing the works they have for sale, will usually be forthcoming with information about the object being viewed, its history, and condition. Reluctance is a sign of potential problems. Knowing what to ask and being able to verify the response is a key part of the process of searching for new works. In other situations, such as the auctions, antique shops, or fairs discussed in the next chapter, help is often available for those who ask for it; the collector must take care to evaluate its effectiveness and candor. Further information and resources are listed at the end of this book.

Historical Significance

Context

In evaluating a photograph or a series of photographs it is important to be aware of why and how they were produced,

and what role they were expected to play in the time in which they were made. A photograph of high quality will transcend such easy categories, but in regard to value, their recognition can assist in understanding the nature, and thus the worth of the picture itself. We may admire many of Edward Weston's works—still lifes, nudes, portraits, images of industry or nature; they are, after all, the works of a master. But in some cases the images will be the result of a commission or portrait sitting, and in others part of a process of personal growth or artistic exploration, that will cause us to see their visual properties in a different light. A classic but frequently unsolved case arises with documentary and expeditionary landscape. Sometimes taken for private railroads, sometimes for the government, sometimes for the touting of properties to investors, sometimes as evidence in court cases, these photographs may well make a collector ask how to determine where the personality of the photographer lies. Indeed, this is a good question. Luckily, some pictures declare themselves. Routine documentary, studio, and commercial work can often be identified by its dry, formulaic quality. Even these, however, have their adherents and thus a certain value. The answer is really that a collector must study the different areas of a photographer's work and have some knowledge of the expectations of the various uses of photography in any particular picture or sector of work. In the case of Weston or other prolific artists, a knowledge of the photographer's career, friends, and associates is helpful. Weston's famous peppers certainly reflect aspects of his artistic growth; his nudes and portraits are often intimately connected with his personal life. In the case of expeditionary landscape the answer is perhaps that the artist's personality may play a part in all of these images—a part whose relative presence could be described with some accuracy on the basis of familiarity and study of the works and career involved.

The subject of historical period and context is important because a still life or scene that appeals to us for its formal values but was taken on assignment as, for example, an advertisement is usually one we will need to assess through different eyes. The typical studio portrait will differ markedly from one in which personal rapport was reached with the sitter. An interpretation of industry meant for the cover of an annual corporate report will probably exhibit a different balance of elements from one meant to hold industry to account. These differences may be subtle, but in regard to aspects of value can help us to understand a particular piece in substantial ways.

Provenance

In all areas of art the specific history of an object is a matter of great interest—even obsession. Given the evident qualities of a certain work of art—the immediate aesthetic and physical character to which we respond—beginning collectors might reasonably question the relevance of its previous ownership and history. The answer is to some extent that art is a matter of taste and values; these too are part of its place on the market. The ownership of a particular piece by an acknowledged collector, or its location during a certain period, can provide a useful perspective on how it has been perceived, and at times offer a confirmation of its qualities. From the point of view of the new owner, it also places him or her in the lineage of the earlier collector or institution to which the piece once belonged. In the instance of especially well-known collectors and collections, the power of the imprimatur can be an important factor in value. When choosing among several fine prints of the same image, for example, the one that had been previously selected for a well-known collection might garner added appeal regardless of otherwise roughly equal aesthetic considerations. In

other cases, information about the history of a piece and its acquisition might show whether it was an exhibition print, an artist's proof, or even a darkroom reject that had miraculously survived. Provenance (the history of ownership) can also be useful in tracing matters of condition and authenticity, especially if the path can be traced directly back to the artist.

As with its provenance, the bibliography, or record of the photograph's publication and reproduction, is an important part of its history as well. Where a piece of art has been published, and by whom, can be an indication of approbation or condemnation (a critical review, for example). How it was published, its context in one book or magazine or another, should offer clues as to how it was seen at the time. In the research presented in the catalogs of dealers, galleries, and auction houses, previous publication of an image will frequently be cited. In most cases these references indicate some legitimate level of interest in the piece—an exhibition, an article, or review of the photographer. Often, however, such citations are not meant to be complete but to provide a quick sketch of useful information within the bounds of the brief, practicable search that the time restraints of such work makes possible. For the full history of an object, as much as is known, a collector might turn to an expert or to a monograph or other scholarly publication whose reputation would be expected to rest on its thoroughness. Both provenance and bibliographical research are time-consuming and demanding. For committed collectors they can also be fun. They are often worth the effort, as they yield important information that can be found or proven in no other way.

Rarity

The rarity or uniqueness of a particular image or print is an important aspect of its value. The relative rarity of multiples

such as photographs can, however, be difficult to determine. In the best of all possible cases you will be dealing with the work of an artist who takes some care in recording and disseminating his or her work. Photographers of the contemporary and modern eras who have worked through galleries, dealers, and publishers are among the most likely to have records, if sometimes informal, of their work: how much was produced, where it went, and sometimes technical information about specific images and their development—information that may assist in establishing differences of value among the individual works of their oeuvre. In other instances the situation may be quite different. Even in the case of artist's records, the work has usually only been traced to its first owner. At this point the files of galleries and collectors come into play. Some do better with this than others. Published auction catalogs can provide similar information, although the efforts of auction houses, dealers, and galleries to protect the privacy of their clients often mean that little further information apart from what has already been published is available.

Frequently, information on the relative rarity of an object is a matter of combined scholarly and market knowledge. In the case of major photographers, catalogues raisonnés have begun to appear, but even these and other apparently unimpeachable sources are in a constant process of being updated. Serious collectors and curators will frequently enter hand notations in these works to keep track of newly discovered (or occasionally destroyed or lost) objects, and new biographical information. For the most part collectors will need to develop a sense from discussion, experience, and research of the relative rarity of the work, or particular images, of artists in whom they take an interest. At times the market itself provides important cues. The highest prices are for the most part reserved for objects of particular rarity or quality. The combination of the two, occa-

sioned by the growth of recent interest in the field, has driven some prices for pieces of exceptional rarity to new heights.

The issue of photography's status as a maker of multiples—that is, art objects produced (unlike, say, paintings or carved sculpture) in numbers greater than one—is a part of its familial relation to the other graphic arts. Like prints, photographs have a plate, the negative, from which multiple images may be printed. In the case of modern or contemporary artists, the number of images may be limited through the production of an edition. In photography information about quantity is not always known. In the heyday of the cabinet card, for example, the exact number of well-known images can only be guessed—the brisk business of accounting for the portraiture of such popular figures as Abraham Lincoln or Sarah Bernhardt would require a study of its own. In addition, the limiting character of an edition depends on the commitment to curtail further printing of the image. Unless the negative is publicly defaced or destroyed, as in traditional printmaking, the true extent of the printing of a work can only be known through historical records or knowledge accumulated through study and in the marketplace.

Opinions differ as to whether the existence of negatives constitutes a danger to market value through the diluting power of quantity or a contribution to the prolonged life of an image through the possibility of reprinting. The contemporary photographer Brett Weston garnered considerable news coverage by burning his negatives. On the other hand, images we would never otherwise have seen emerge in a relatively constant stream as prints from archives where their negatives have been protected, often since the dawn of photography. Weston's faith was clearly in the importance of the market for photography, and his effort was directed at putting his works, and that of others who shared his views, into the same category as that of

other fine, and rare, art. This is one view of rarity and value; others prefer to let history take its course, and to value images and prints simply for what they are, without the direct intrusion of the hand of the market.

JUDGMENTAL FACTORS

Beauty

The concept of beauty is today much embattled, and frequently maligned. Since the late nineteenth century, and especially in the twentieth, other standards have boldly made their way into the creation and appreciation of art. We no longer accept the notion that a work of art is of value simply because it is beautiful, if indeed that state can be agreed upon at all. Certainly canons of beauty change. Impressionism was once despised; it is now again being questioned; in between it was one of the most popular movements in art of all times.

While beauty may be an endangered concept, affected equally by changes in the world of politics and art, it remains true that works of art are collected by people who care for them, and that except in the most perverse of instances the aesthetic sense plays a role in their judgment. To translate the quality of beauty into more modern terms, it might be said that while it remains one of several key aesthetic qualities in the consideration of art, it no longer stands alone as it once did, and represents instead a level of interest or appreciation that may today be expressed as admiration of other kinds. No one buys art they hate; they may however buy art that expresses hate, rage, and other negative emotions. In their own way such pieces may be said to be beautiful to their beholder: powerful, articulate, elegant.

In regard to photography it should be said that the beauty of

an image, in the traditional sense, is more appropriate to some eras, schools, and artists than to others. A raucous and unsettling image in the calm, classicizing pages of Stieglitz's *Camera Work* is a rarity, while one produced by the Soviet avant-garde of the same period is an illustration of the characteristic novelty of its vision. Each is valid in its own way. Some pieces, such as those of Heinrich Kühn or Robert Demachy, are obviously intended as rich visual experiences in which paper, ink, and artistry in printing purposely extend and deepen the image. A roomful of such prints could, however, be overwhelmingly rich, and stifling in its bounty of diaphanous forms. Such are the limits of the traditional concept of beauty, and pictures purchased solely on their pleasing merits ought to be the very best that can be found, as lesser pieces will inevitably be pushed out by better examples of their kind. Conversely, strong pictures, even of contrasting types of beauty, often go together well. Their strengths, however different, frequently turn out to be complementary, and their similarity of emotional intensity overrides any superficial differences of subject or tone between them. Beauty in this larger sense is intimately mixed with concepts of value; that of its lesser, superficial role is merely a quality, like many others, contributing to the overall content and meaning of an image.

Quality

Determination of the quality of a photograph involves a combination of judgments based on the sort of considerations we have discussed in this chapter (image, artist, medium, relation to style and school, etc.), and no doubt other relevant factors in individual instances. It is important to remember that there is no absolute measure of quality. Taste changes; increased knowledge contributes to new points of view. Within specific

parameters there are well-defined standards of quality: the best print, or type of print, of a certain image is often widely agreed upon. But that print, or edition, is one of a larger number produced by the photographer. There are few responsible practitioners in the field of photography who would assign permanent measures of quality to individual works. As your collecting becomes finely-tuned, issues of quality will sort themselves out along with other decisions concerning which photographers, schools, or subjects to collect. For the beginning collector, the operative notion about quality is that it is in a general sense relative but that the recognition of levels of quality in specific areas, such as image, paper, and printing, will help in making judgments about the sort of photographs to collect.

Value

Like quality, value involves an amalgam of attributes. Although established values exist in the market at any particular time, determining a probable range in which prices of individual pieces are likely fall, these are flexible guidelines of what a collector might expect, rather than standards of an absolute sort. Value of a specific piece is determined by a balancing of the most important of the many factors of which we have spoken; against this you must juxtapose market considerations that may move a competing collector or institution in his or her quest for the same object. Barring extraneous forces (which from a practical point of view always need to be taken into consideration), a combination of a competent assessment of the object with a reasonable appreciation of its worth to others will yield an accurate sense of its value. With this information in hand, facing a dealer, gallery owner, or auction sale is achieved with considerably less fear or risk.

Price should reflect value, but of course this does not always

occur. To some extent the price of a photograph is determined not only by the work itself but by the source from which it is acquired. With some ingenuity a high-quality print may be obtained at a surprisingly low cost; overpriced work is not unheard of, either. Both are functions of the circumstances under which specific work, or bodies of work, are offered for sale, in combination with the competition—or implied competition—that may be asserted to exist for the work or works in question. In determining a reasonable price for a work of art, many factors need to be considered, such as those of artist, condition, rarity, and others mentioned in this chapter. To this may be added the effect of any intangible considerations: recent notoriety, adverse publicity or scholarship, or any of a host of other relevant contingencies. For good measure, an assessment of your own resources will often provide a critical element to limit the reasonable range of price.

6

WHERE TO FIND PHOTOGRAPHS

For many collectors the search for photographs—and the research that supports it—is one of the most exciting and fascinating aspects of their collecting. In this chapter we will follow the lives of some types of photographs before they enter the market in order to see where they might be found, and where to look if they cannot. We will then investigate the market in its various forms—galleries, dealers, and auctions—to review the most typical ways that collectors collect. Finally, we will look at some related areas of collecting, corollaries to photography that may be of interest to those who collect it.

PRE-MARKET
The Life of the Photograph

Works of art often travel along paths well known to those familiar with them, along with the allied worlds of art produc-

tion and collecting. To be able to find the photographs you want, you need to be familiar with some of these paths, and be able to speculate on new ones you may encounter in your search for pictures.

Photographs are produced by photographers. The trail thus starts in a studio or darkroom. Although many collectors, except in the contemporary field, never see the studios the works they collect come from, it is helpful to know something about studios and the working habits of the photographers in which you are interested. Some photographers, for instance, are individuals working on their own, while others may be employed by an agency or publisher who distributes (either more or less successfully) their work. Photographers may mix professional and artistic work; they may travel to get the views they are known for; they may belong to organizations and groups. All of these—type of work, location, and contacts—may be helpful in tracing the existence or availability of work.

Beyond these, the range of distribution of an artist's work and the actual form it takes are key considerations. As a young man, the American photographer W. H. Jackson started a small studio in Omaha with his brother from which production was relatively modest. He later worked in the West for railroads and government surveys, producing images that had larger but often limited spheres of publication and distribution. Following this, he founded an ambitious and productive studio in Denver, from which images were widely distributed. The set of negatives he printed and marketed from Denver were later incorporated into the stock of a much larger company in Detroit, and their range of distribution increased. All of these considerations affect where Jackson's photographs might be found, and in some cases the quality of the pictures themselves. The Detroit printings are, for example, sometimes mass market items (postcards, stereos) that would not at first be considered

the work of a master, while the prints Jackson made or super-
vised himself are quite different. Such career considerations
can also relate to matters of meaning in the works. Knowing
this history, a collector is aware of Jackson's ultimate trajectory,
and the early appearance of a professional, somewhat imper-
sonal tone in his work might come as less of a surprise.

Photographers are of course surrounded by family, friends,
and associates. Besides the formal distribution of photographs
through clients, galleries, publishers, and agents, a number of
pieces often make their way into the world through these infor-
mal relationships. Tracking down work of a particular photo-
grapher or school will probably involve knowing the extent,
location, and membership of the groups to which the photog-
rapher belonged, and the importance of any related bonds.
Photographers are likely to give or sell work to friends and
family, to students, to associates or peers (sometimes by
exchange), and to neighbors. Work is sometimes bartered for
services, purchases, rent, or it may be contributed to the collec-
tion of a professional organization to which the photographer
belongs. Certain figures, such as teachers and mentors, are
magnets for the work of photographers. The personal collec-
tion of Alfred Stieglitz, who was not only a photographer but a
gallery owner, publisher, and mentor, contained many works
by other artists as well as his own. Similarly, in looking through
the work files of any particular artist, such as those collected by
Stieglitz, it is not uncommon to come across pieces made by
others and acquired by purchase or exchange. The attribution
of authorship in such cases, especially when artists have been
working together or under shared influence, can be challeng-
ing and difficult.

Given the circles in which a particular photographer func-
tioned, personal, professional, and public, one must ask where
the works produced might be likely to reside. A studio may

have an archive, or the works may be in a repository related to their geographical or other nonphotographic status. Local institutions where a photographer developed his or her career may hold some of them, as well as others farther away, at locations where the artist later lived and worked. The files or morgues of agencies, publications, or other organizations through which a photographer was employed may hold prints or documents of various kinds. The disposal of the estate of an artist, which may contain original works, is usually traceable through public papers; the estates and families of the artist's friends and associates are worth watching as well. Collectors are another resting place for work. Often large lots or bodies of work are bought in order to corral a few particular pieces; the remaining works may be of interest to others.

Beyond these more or less direct lines from the studio to repository, some ingenuity is required to trace works of art. Families and organizations move; new generations emerge with no memory of what was important to their forebears; the priorities of institutions change. All of these lead to the relocation or neglect of material that may be of considerable value. Further changes may bring them to light, but not always. Thus the work of an early twentieth-century artist could be found in the attic of a house once occupied by his or her family, or perhaps in rented storage, along with other items not retrieved by descendants or heirs. Institutions may "deaccession" material to avoid duplication or to implement a change of focus in their collections; such pieces could then appear anywhere from a local flea market to a national auction house. They may also be acquired by observant dealers and find their way directly to the market.

Collectors often look for signs of change. Economic developments, changes of taste, and notoriety affecting the reputation

of an individual or school of photographers are some of the circumstances that could lead to the discovery of work. The movement west of settlers in America has dispersed art and artifacts formerly associated with the East to Ohio, Kansas, and other points in the Midwest, and from there sometimes to California or other far western locations. In succeeding years they may have moved again. Developments in Eastern Europe during this century have led to the arrival in Western Europe and America of newly available photographic material from that area. Such movements and changes are constantly occurring, making the identifying and tracing of work a matter of considerable imagination and creativity.

A collector needs to recognize, or be able to conjecture, who would know of or have recorded changes and developments. Photographers will always take an interest in the work of their peers; these and other related professionals or amateurs may know something about the career of an artist forgotten by others. The clubs to which a photographer belonged (camera clubs were once an important aspect of the field) may have records, archives, publications, or even a collection. Publishers and printers who handled original art may have it on file; in some cases it is highly valued, in others almost forgotten. Families of photographers may have an informal designated historian or archivist, a family member focused on its achievements and traditions; the families and associates of the subjects of portraits or other images should be considered as well. Archivists, librarians, curators, and other professionals have a wide-ranging knowledge of overlooked materials they may have encountered in their quest for the papers, books, or art mandated by their institutions; dealers and gallery owners do not buy all that they see and can often recall a trove of material that seemed at the time of lesser importance. Again, other collectors

are a resource. Unless in direct competition, camaraderie is often their preferred mode: most agree that more is found through sharing information than by guarding it.

These are some of the many ways photographs may progress from the artist into the public realm. Another is of course through the direct intervention of the artist. In a search for works, collectors should not overlook the availability of editions and portfolios produced by artists with the specific intent of offering them for sale. These are frequently handled by galleries or dealers, or sometimes by the artist. Limited editions and portfolios, though developed largely as a marketing tool, do offer some advantages: the work is presented in a manner approved by the artist or an authorized designate, and in the case of a portfolio it often comprises a suite of related work, which might be difficult to duplicate on the open market. Such offerings are frequently presented matted and cased, a welcome service to most collectors.

THE MARKET

Galleries

Galleries are probably the part of the photography market most visible to the public. They are indeed intended to be public and to present photography in a way that invites curiosity and interest. The number of photography galleries is smaller than that for painting; the relatively lower cost of individual pieces of photography frequently prohibits the high rents galleries must pay for visibility. Over the past twenty years, however, major cities, and even some smaller ones, have seen considerable growth in serious photography galleries. They have emerged not only in New York, Los Angeles, and San Francisco

but in areas such as the Southwest, which was considerably less developed before.

Photography galleries usually have on hand a reasonably large selection of work. Their facilities and their resources are finite, however, and some choices have been made as to which works they will carry. Often a gallery will specialize in a certain period, artist, or group of artists whose work they hold in depth. A selection of photography may also be held by other art galleries, such as those of contemporary art or those handling prints and works on paper. In these cases photography is sometimes treated as a separate medium; in others it is represented because one or more of the gallery's artists chooses to work in it, or because it plays a part in their work in other media. (Photographs printed as gravures or lithographs, for example, are often treated as prints, and sold as such.) Galleries hold regular exhibitions and often produce publications, usually of modest proportions. Gallery openings may be a good place to familiarize yourself with the collecting community; brochures or other published material provide a quick and useful take on whatever work a gallery is presenting and artists it represents.

As with the other sectors of the market, galleries offer professional consultation and other services for potential collectors, advice that can be very useful. As with the art itself, though, it differs widely from gallery to gallery, and though you may well develop a close relationship with a particular gallery or galleries, others may not provide either the sort of art or advice you need. A good relationship with a gallery might entail discussions of artists or work you are pursuing, and of specific works or alternate pieces you might practicably be able to find. In a serious relationship with a gallery, searches will be made for the work you are seeking. The expectation is that you

will take enough interest in the work to justify the expenditure of time and resources spent in bringing it to you.

Visiting galleries for a firsthand education in the subtleties of an artist's oeuvre or technique is part of the important effort collectors must make to train their eye and to experience as wide a range of work as possible. The accessibility of many galleries, often located in retail areas, makes them a good destination for a midday or late afternoon break from work, or an informal and revivifying visit on the way home.

Although galleries do offer useful services and provide a museumlike setting for art, they also represent the tip of the pyramid of value for a photograph. Once a photograph is in a gallery, it has already climbed the long ladder from obscurity or private ownership to a place in public view. To justify the level of presentation, display, and services offered by galleries to attract buyers, prices tend to be higher than in other places in the market. On the other hand, galleries perform the important function of bringing work to public attention and provide a satisfying retail setting in which shopping from highly accessible walls or nearby storage drawers is made easy. For most collectors, a gallery will be the place to go for certain works and will provide a good introduction to collecting, while a different and complementary range of pieces and services will be found in other sectors of the market.

Dealers

The photography dealer shares many of the essential qualities of the gallery, but the practical difference is that he or she may not have a gallery at all. As photographs are eminently transportable and easy to store, a number of photography dealers have emerged who work out of their homes or from an office less public than a gallery. Since for the most part they are

sought out by serious collectors and not by the general public walking in off the street, they often take a freer approach to the pursuit and presentation of material.

At the dealer's office, or in the portfolio he or she may carry on their frequent travel, pieces are seen, relatively speaking, in the rough. Such work, though often matted, or if unmatted kept in folders for protection, seen outside the context of a gallery, museum, or framed in a home requires a bit more inventiveness and concentration on the part of the viewer. Some collectors prefer this mode of interchange. Certainly it is more direct. The dealer's prices may also reflect the lower over-head of not having to maintain a public forum for the display of work, although the scale of prices varies, of course, with the quality of particular pieces. Given some of these considera-tions, the dealer is often able to present work that may be more specialized and less appealing to the general public—work that a gallery may well have available but not on display. A dealer is also somewhat more at liberty to go in search of work requested. The result can be more personal attention and con-centration on the special interests of the collector. Certainly this can occur in the context of a gallery as well, as it often does, but the fact remains that not having to mind an exhibition space with its allied programs and services, the dealer is freer to con-centrate directly on the needs of clients.

The question a collector needs to ask in looking seriously at either a gallery or a dealer is whether sufficient rapport exists, or is likely to develop, between him- or herself and the person or business in question. Does the dealer or gallery take an inter-est in the collecting you want to do? Can they supply helpful information or other useful tools? What sort of commitment do they have to the kind of material you want (do they have a his-tory of offering it; do they serve other collectors in your sector of the field)? As with galleries, dealers will probably occupy a

specific position as one of several approaches to the market a collector will take. Although a dealer may offer a more fine-tuned, possibly less expensive approach to finding work, the activity generated by galleries is also useful in its own way as a locus where the artistic and social aspects of collecting meet. Probably some balance between the two will need to be struck.

It should be added that in the case of both galleries and dealers, increase in the use of phone, fax, the Internet, and express mail has led to relationships in the world of art, as in other fields, in which visits may not always be necessary. Once a relationship has been established, many collectors, knowing roughly what they want and able to speak with some clarity about photography, will call a gallery or dealer and arrange to see some work on approval by mail. This is a convenient way to shop, and though one would not want to ask frequently for this service at the expense of the resources and time of working professionals, the needs (and sometimes the whims) of serious collectors to see new work are usually likely to be honored.

Finding reputable dealers and galleries and confirming their reputations, though to some extent a matter of personal style and taste, is an area in which common sense and the typical practices of business and other professional relationships prevail. The recommendation of friends or of other collectors is a good starting point. Checking with a gallery or dealer association, such as Association of International Photography Art Dealers, can yield not only the location and identity of their members but often some sense of their relative status. Once found, supporting information should be sought from those who have used a particular dealer or gallery—previous or current customers whose experiences will inform your own. It is good to keep up with individual galleries and dealers. Personnel and other professional circumstances can change

swiftly and may affect how business is conducted. In a case where good personal rapport has been established, it may make sense to follow an individual expert from one gallery to another rather than to remain loyal to a business whose tone has changed with his or her departure.

Auctions

The third major area that serves the market for photography is the auction house. Photography auctions have been conducted on a regularly scheduled basis since the revival of interest in the medium in the mid-1970s. The major auctions, currently scheduled in fall and spring, are attended by many in the field and are preceded by previews of the material to be sold, which, at least in American auction houses, amount to exhibitions as interesting in their own way as those presented by any museum. (London auctions take a different approach—one must make a time-consuming search through the material at tables to see what is coming up for sale.) At the major auctions, although the general quality is high, usually a wide variety of material is presented, ranging from extremely valuable pieces to those of lesser interest or more doubtful condition. Within the upper end of the scale, the scope of quality, condition, media, eras, and artists is as wide as will be found anywhere. The opportunity for comparisons, as well as the company of visiting collectors, dealers, curators, and scholars make the auction previews an excellent occasion for education, as well as a preparation for the sales they serve to introduce.

The primary importance of the auctions is that they represent a separate pool of material. Although some of the pieces may have passed through the hands of dealers and collectors, their appearance at auction marks a certain point of public

accessibility. In some instances, work is floated to test the market for particular artists, periods, or subjects; in others, work may be consigned from sources previously unknown. Museums frequently deaccession through auctions in order to put duplicate pieces or those inappropriate to their collections out at fair market value, and reach the largest possible range of the buying public. Entire collections are sold in which pieces thought to be off the market reappear. There is a luck-of-the-draw quality to these events, a set of constantly changing conditions and mood that has to be witnessed to be appreciated. The democratic blend represented by the auctions—free access to material and competition for prices—in combination with the expertise available from the company of other interested collectors, dealers, and scholars assembled, as well as from the staff of the auction house itself, make them an experience of importance to collectors new and old.

Generally, because of larger size, staff, and resources, a wider range of services and publications is offered by the major auction houses than by galleries or dealers. Besides the experts who are available for consultation and the previews described above, educational programs, seminars, and talks are often held, many directed at potential and beginning collectors. Catalogs for each auction offer reference material, and often a reproduction of virtually all pieces to be auctioned, as well as a post-auction list of the final prices paid (available on request), which are extremely useful tools for tracking images, artists, and values. Such information supplied by auction houses, as well as other published sale and price records, are often available for consultation through art libraries and the print and photograph departments of galleries and museums.

Auctions employ a venerable set of protocols relating to bidding and value. An explanation of these, in basic outline form, is usually found at the beginning of any auction catalog but

William Henry Fox Talbot
(British, 1800–1877),
*Asplenium Halleri, Grande
Chartreuse 1821*—
Cardamine Pratensis,
photogenic drawing,
20.5 × 17.0 cm, April 1839.
THE J. PAUL GETTY MUSEUM,
LOS ANGELES.

Anna Atkins (British,
1799–1871), *Thistle,*
cyanotype, c. 1843.
COURTESY MUSEUM OF
FINE ARTS, BOSTON.

Charles Richard Meade
(American, born Britain,
1826–1858), *Portrait of
Louis-Jacques-Mandé Daguerre*,
hand-colored daguerreotype,
image: 16.0 × 12.0 cm,
mat: 15.8 × 11.5 cm, entire
object: 22.1 × 17.7 cm, 1848.
THE J. PAUL GETTY MUSEUM,
LOS ANGELES.

Albert Sands Southworth
(American, 1811–1894) and
Josiah Johnson Hawes
(American, 1808–1901),
Harriet Beecher Stowe,
quarter-plate daguerreotype,
c. 1843. HALLMARK
PHOTOGRAPHIC COLLECTION,
HALLMARK CARDS, INC.,
KANSAS CITY, MISSOURI.

Unknown photographer, *The Beautiful View of Rome*, albumen
print, c. 1868. THE J. PAUL GETTY MUSEUM, LOS ANGELES.

Carleton Watkins (American, 1829–1916), *Cape Horn, Oregon*,
albumen print from glass wet plate negative,
40.5 × 52.3 cm, negative 1867, print c. 1881–1883.
THE J. PAUL GETTY MUSEUM, LOS ANGELES.

Robert Demachy (French, 1859–1936), *Jack Demachy, Age Eight*,
gum bichromate print, image: 15.9 × 11.2 cm, sheet:
17.5 × 11.3 cm, 1904. THE J. PAUL GETTY MUSEUM, LOS ANGELES.

Laura Gilpin (American, 1891–1979), *Basket of Peaches*,
autochrome, c. 1912. © 1979, AMON CARTER MUSEUM,
FORT WORTH, TEXAS, BEQUEST OF THE ESTATE OF LAURA GILPIN.

Dr. Harold E. Edgerton (American, 1903–1990), *Bullet Through the Apple*,
stroboscopic photograph; dye transfer print, 1964. © HAROLD &
ESTHER EDGERTON FOUNDATION, 1998, COURTESY OF PALM PRESS, INC.

Jo Ann Callis (American, 1940–), *Parrot and Sailboat*,
dye transfer print, 1980. LOS ANGELES COUNTY MUSEUM OF ART.

Stephen Shore (American, 1947–), *El Paso Street*, *El Paso*, *Texas*,
chromogenic print, 1975. SAN FRANCISCO MUSEUM OF MODERN ART.

Richard Misrach (American, 1949–), *Waiting, Edwards Air Force Base*,
Ektacolor plus print, 1983. COURTESY FRAENKEL GALLERY, SAN FRANCISCO.

David Levinthal (American, 1949–), *Untitled*, from "Western Series,"
Polaroid print, 1988. © DAVID LEVINTHAL, COURTESY HALLMARK
PHOTOGRAPHIC COLLECTION, HALLMARK CARDS, INC., KANSAS CITY, MISSOURI.

they are probably best learned by observation, with some guidance either from an experienced bidder or from the staff itself. Estimates of value are stated in the catalog, but they are only that. For some objects there may be a base value (the "reserve") that the consignor of a picture establishes with the auction house as the lowest acceptable price; if this is not reached the object is not sold (it is "bought in" by the auction house). Many forms of bidding exist, including discreet methods such as private signals between buyer and auctioneer and bidding over the phone. Some potential buyers choose to have their bidding done by others, usually a dealer who will charge a fee for the service. Often there is no way of knowing exactly against whom one is bidding. Competition for a particular piece, artist, or period may drive certain prices up beyond the level of comfort; similar neglect may depress them to the point that bargains can be found. In between, the normal vicissitudes of attention span, gossip, and personal revelation play a role of some importance at a live event such as this. These and other habits make auctions both trying and exciting. When important works or bodies of work come up for sale, you can be sure that committed institutions and individuals will be vying for them; being a part of this process is both challenging and satisfying.

Major auction houses can be found in the larger cities. In New York, the principal biannual photography auctions are held in the fall and spring at Christie's, Sotheby's, and Swann's. Christie's and Sotheby's have international and regional branches as well, and Swann's is a member of a larger consortium. Butterfield's in California or Skinner's in Boston are examples of somewhat smaller concerns at which interesting work may appear. Less prominent auctions in which photographs may come to light occur with some frequency on a regional or local level. The major auction houses also regularly have smaller sales besides the large semiannual ones. The sale

of particular estates or consignments, in which lots of photographs may appear among other objects, come up with some regularity. Those who take the time to look will often find something of interest.

Fairs

A relatively recent development has been the popularity of art fairs. These events, at which particular media and forms of art such as prints or antiques are featured, may contain photography. Through fairs, dealers and galleries work together to present their wares in a central location. According to which dealers and galleries chance to attend, such fairs and shows may be more or less rewarding. They are usually worth a look, in any case.

Fairs and shows devoted specifically to photography have grown considerably over the past few years. The biggest is probably the annual show mounted by the important photography dealers' association AIPAD in New York every winter, at which some seventy-five galleries and dealers are represented, but similar events occur in Los Angeles and other locations. Houston, Texas, hosts an immense biannual festival of photography, Fotofest, focused primarily on contemporary work. Britain and France also have periodic festivals of photography. At these shows collectors are exposed to the full range of pictures available on the market. The fairs offer a good chance to meet a diverse set of photography professionals and see the work they handle. As with auctions, the material at fairs varies tremendously; usually there is some very affordable material as well as a strong representation from the high end of the spectrum. A visit to a fair in New York or Los Angeles, or to one like them, provides an invaluable introduction to the field of col-

lecting. Similar works can be compared, as can the working styles of those who handle pictures for a living, sometimes a consideration of equal long-term importance to a collector. As at the auctions, key players in the field will be in attendance at the larger fairs, and the ambiance is one of excitement and discovery.

Hunt and Peck

Shopping on your own is a good way to test out an interest in collecting. Almost every area hosts a number of flea markets or shops; tag sales are ubiquitous. Libraries divest themselves of books (some illustrated); attics are emptied. All of these may be sources of photographs. Not infrequently a frame for sale as a piece of furniture will contain some forgotten photograph or print. Antique, art, print, and frame shops are among the most promising, but good material can be found anywhere—that is, it can appear anywhere unexpectedly, though in this context it is not always easy to seek it out directly. How an individual collector deals with this equation, availability versus quality, pure luck aside, is likely to shape both the collecting habits and the collection that develops. A person fairly sure of his or her taste, with a good command of photographic history and media, cannot go wrong even among the myriad booths of a tag sale or swap meet. On the other hand, the likelihood of finding a neglected masterpiece among old stoves and hats is far less than it might be in other, more focused locations at which a higher price would be paid. When shopping on your own, the price paid is generally the time spent in the search. When looking in galleries, auctions, or other more specialized locations, the higher price you are likely to pay helps to defray the cost of such a search by someone else.

The above considerations lead to what I have come to call the syndrome of Ellen's Treasure Hut, an establishment (or someplace very much like it in some other incarnation) I pass with some frequency in my travels. Such enterprises always lure us with the enticing thought that what Ellen has assembled may in fact be the treasures she advertises. Other instincts remind us, however, that if this were so, she might not still reside in a hut, or if so, would have fixed its leaking roof. The effort taken to investigate such opportunities is better justified as leisure time than as a search for art. While certainly the possibility of local, regional, and family treasures should be investigated on an ad hoc basis as they come up, the troubling thought remains that even if found, one must hope that such treasures were not kept in the particular place over which, as at Ellen's, the roof leaked.

Additional Advice

When shopping on your own, without the advice of a professional guide who knows the field, or perhaps just in the process of getting started with collecting, probably the most frequent error is to mistake for a photograph something that is not. A wide range of prints exist that are intentionally made to resemble photographs. The most obvious are posters and reproductions. Especially when matted or framed these can be difficult to distinguish from original work. Only familiarity with photographic prints, and if necessary the use of the magnifying glass carried by serious collectors and scholars in all fields of art, can make such issues clear. Don't be shy about it; as a buyer, it's your money on the line.

The second most frequent error, less common because the work itself is rarer, is to overlook a photograph thinking that it

is something else. The hand-worked images of the turn of the century, painted photographs, and other hybrid media that may look like paintings or prints but are indeed based on photography can be a source of confusion. Again, acquaintance with the various forms of prints is the only cure. Your response to these pieces will depend on your taste and collecting goals— some pieces will be appropriate and good, others not; but if clearly identified as photographs, they can at least be considered for what they are.

For those with a serious interest in photography, a representation of the various levels of knowledge about pieces coming into the market, a structure reflecting the photographic community itself, might be expressed roughly as follows: typically a collector buys a picture from a dealer, gallery, or auction— individuals and institutions with a great deal of experience in the field, but who typically operate out of offices far from the source of the photograph. How then did it get there? Many dealers and gallery owners travel to find work. They depend in turn on their own connections, a set of freelancers and entrepreneurs who spend a considerable amount of time trying to uncover and identify new work. These operatives, often found at lesser auctions and better antique shops, compose an informal network through which much newly found or identified photography comes to market. Getting ahead of them is difficult, but not impossible. The key is to be out looking as much as possible, and of course to know as they do where to look. Time spent along the collecting trail, at the small auctions and shops at which material sometimes turns up, and getting to know those who frequent or run them, is a good way to position yourself close to the source of new work. Often, if your interest is known, you may be able to hear about and consider a piece long before it enters the market.

RELATED AREAS OF COLLECTING

Many areas of collecting are tied directly or indirectly to photography. Among the most obvious corollaries to the field are prints that involve photographic images or technology in some way. Prints and posters both have large followings among collectors, as do the specific media of lithography and gravure, and the more recent screen print. The large number of photographic publications, especially, but not exclusively, those with high-quality illustrations, paper, and design also offer a wide arena for collecting. Photographic equipment, from the camera on down, is avidly pursued, and the new area of movies and film, both stills and entire reels, as well as the related ephemera of the film world, are hotly contested items at auctions and sales.

These are just a few of the possible areas into which a collector might venture using an interest in photography as a base. The point to keep in mind if a collection is to be related to photography is how it links to the related field. In the realm of other media (prints, film), you might seek out the work of artists you admire in photography. In regard to publications, your interest might be that of the bibliophile in the often elegant volumes themselves, or in widening your coverage of the work of a particular artist, era, or school. Such objects of collection also offer the opportunity to assemble closely related variant images, or variant printings of the same image, matters of interest to lovers of prints in all media. These and other considerations that link the work of photographers to diverse media or to more specialized sectors of their own field, hold the potential of an inspired and unusual collection.

7

PLANNING A COLLECTION

Planning a collection requires a set of goals, the preparation necessary to pursue them intelligently, and the commitment to persevere in their execution. Beyond that, it draws on the collector's knowledge of the market and the medium to reach a reasonable balance between the ideal of the particular work sought and the reality of what may be available or affordable. Together these elements, discussed below, guide the formation of a collection, lie behind the work needed to make it a reality, and lay the foundation for the many things that can be done with a collection, once assembled.

GOALS

Creating goals for your collection can be either an intuitive process or one of strategy, or more likely a bit of both. In each

case the questions, in brief form, are: Which aspects of photography interest you? Which photographs reflect a reasonable possibility of acquisition? What sort of collection will result? The intuitive response is to tend toward a collection that is personally pleasing, reflecting your taste and views, and in which some latitude is allowed for the expression of the collector's individual interpretation of the overall assembled works. A more calculating or strategic response would probably take into greater account the objective standards of the field: great works, well-known artists and oeuvres, and the role a collection might play in the larger field of photography. In each case some important choices have to be made.

Which Aspects of Photography Interest You?

The photographs gathered to form a collection are likely to be of interest for one of two reasons: they are personally appealing or of historical or artistic significance. Both are legitimate standards to apply. The first may be more risky, but on the other hand more uniquely satisfying; the second more firmly grounded but more difficult to achieve. In both cases, knowledge of the field of photography is essential. Suppose, for example, a potential collector were to come upon the work of a little-known British photographer of the late nineteenth century. The images are pleasant, the prints are good, the subjects—let's say landscape and architecture—are of interest. From the point of view of the personally oriented collector, buying work like this would make sense. The criteria for collecting (enjoyment, satisfaction, a modicum of knowledge) would be easily satisfied. Since the goal of this type of collecting rests squarely on personal response, other questions, such as market value or historical importance, may not need to be asked, although they might provide, if answered, a second line

of defense for this purchase. For the collector oriented toward historical or artistic distinction, however, certain further questions would need to be asked. The images may be appealing, but are they significant? The prints may be good, but are they vintage, lifetime works produced by the artist; are they gravures or some other form of mechanically produced edition? Where do they stand in the career and oeuvre of the artist; is the artist him- or herself known for any sort of important innovation or contribution to the field? Are the pieces rare or usually easy to find? In the instance of each collector, acceptance or rejection of the works would indicate that a goal had been met: in the first, that of satisfying the individual taste of the collector; in the second, that of assembling pieces composing a certain sector of an artistic history.

These works would not be of interest to a collector focusing on French photography, on early British work, on contemporary work, or any number of other diverse areas of the field. They might not even be of interest to a collector working in this nationality and era, if they were the work of a minor artist, or represented a lesser chapter in the larger oeuvre of an important artist. On the other hand, to a beginning collector whose focus is not yet fully defined, these works might represent an advance in taste and, if affordable, provide an important lesson in the appreciation of aesthetics, history, or technique. If they are good at all, they could also be deaccessioned at a later time to make way for higher quality work.

Such choices rely on a sense of which aspects of the field are of interest to a particular collector. Aesthetic response, a sense of history, personal, geographical, or institutional ties to the artist are all examples of affinities that might draw a collector to particular work. Some collectors favor certain kinds of prints, such as pigment, platinum, or one of the various kinds of contemporary color print; others are drawn to photographs

on the basis of subject or theme. Having a working knowledge of your taste and motivation in collecting is essential to resolving the choices collectors frequently have to make. Any piece can be added to any collection, but the question is, is it the centerpiece of the collection, or a peripheral piece? does it play a supporting role to fill out the collection, or take it in a new direction? Sometimes the odd piece that does not fit may turn out to represent the beginning of some new interest of which the collector was not fully aware. Standards and opinions can change; what is important is that a collector continue to work at staying in touch with such considerations as the collection itself develops.

Which Photographs Reflect a Reasonable Possibility of Acquisition?

An important part of collecting photography is to identify a sector of the field that is accessible. This would principally include availability and cost. To assess these, a knowledge of the photography market, and if possible its infrastructure (where pictures come from, who is likely to have them), is essential. For beginners, a sense of a local market and its related context is a good place to begin—finding photographs in your area, and developing through your own research and shopping a sense of what photography is available and its relative value.

At the high end of the photographic spectrum are likely to be works of great interest but often beyond the means of most collectors. By definition the number of these works are usually limited, making their purchase an accomplishment of both strategy and resources, as well as, of course, the taste and knowledge evidenced in the decision to acquire them. Such

works might be the object of long-term planning—a piece that would cap off a collection assembled to provide a context for it, for example, or that might provide a cornerstone on which a collection might be built. These are two ways of looking at the same concept: a unified collection. The processes and their results, however, could be quite different: The collection that grew from a single piece could go in a number of different directions, while the one reflecting the capstone or tip-of-the-pyramid approach is carefully preconceived.

Needless to say, works like these are relatively rare. Collections of only the highest quality works are likely to be either comparatively small or represent the presence of substantially greater resources. While there is no denying the satisfaction offered by such works, there are many other more accessible parts of the market. To enter these, peruse auction catalogs, or visit galleries and dealers to see where current prices meet your requirements of interest and taste. Often areas of the market can be found that fit the interest or needs of an individual collector but also represent byways to others in the field. In these areas, values are likely to be better. Niches can be uncovered in which collecting needs to be done and works are available at a reasonable price. Identifying such a niche can provide a sense of direction and purpose to a beginning collector, as well as the satisfaction of bringing together works of a common medium, artist, or theme. The collecting of gravures, for example, combines the advantages of one of the most permanent of photographic media with a cost lower than those of the prints from which they were made. Artists not at the peak of their recognition represent a similar opportunity. Often artists have contributed significantly to the field of photography but worked in a style currently out of favor. If such work falls in your area of interest and taste, you're in luck. The same

is true of contemporary and modern work, a field in which tomorrow's masters are still in the process of definition. Good judgment here could lead to a trend-setting collection that might create value of its own.

A recent example of a collection formed through a strategy like those mentioned above was assembled by a collector in the Midwest. While the works of Clarence White are well known and often of considerable value, those of his many students were relatively unknown and little collected. Research and the work of a consulting curator produced a collection that offered the public its first view of the work of White's students, an exhibition and a publication of national importance.

In all of these cases, the point is to adapt goals of taste and value to the realities of availability and price. The result will be an objective whose accomplishment is not only satisfying in the abstract, but more important, attainable. You may on occasion stretch above or below the general goals established for a collection (life would otherwise be rather dull), but having such an overall plan or vision is an irreplaceable point of departure for the work to be done.

What Sort of Collection Will Result?

Photograph collections are as varied as those who assemble them. Given your goals within the medium and the availability of the pieces desired, you next must consider what such an assemblage of work will be like, what can be done with it, and what obligations it entails. Often these are choices of levels of participation and achievement. A personal collection whose satisfaction is not dependent on exhibition or publication can be kept simply, shown for the appreciation of colleagues and friends or displayed on the walls of an office or home, with lit-

tle trouble. Such collections are frequently as satisfying to their owners as more august aggregations of work, possibly proportionately more so, since less maintenance and obligation are involved. Other collectors, however, define their interest and satisfaction in collecting at least in part through the demands of public participation emerging from ownership of a body of significant work.

In either case, it is important to envision the result before you begin to collect in earnest. The personal collection will have an immediate audience: yourself, your family, and your associates and friends. For the more ambitious collector, a goal of exhibitions, lending, and publication might shape the choices of work acquired. Issues related to cost or personal taste might be secondary to those of subject, artist, or era— factors that, through ambitious collecting, could complement, expand, or even change a particular sector of the field of photography. These collections involve a more complex set of goals: establishing through research or consultation the need for public programs (exhibitions, publications) in a certain area of the field of photography; the exposure of new or little-seen work for the benefit of the public and professionals in the field. The extent of resources necessary to support involvement in such programs must be ascertained, along with the accessibility of suitable institutions with which to work. In general, it can be said that collections with a public face entail a level of involvement satisfying to some and daunting to others. In forming a collection making a choice between the two very different goals of public and private satisfaction will avoid later confusion, disappointment, or frustration.

Other important aspects of a collection are its size and general type. Size is likely to be determined by market values and the resources of the collector, as well as by the availability of

the work you seek. In addition there are physical considerations such as management, storage, and conservation: how many pieces are you willing to take care of in a responsible way? In regard to types of collection, the range is great. For some collectors, a few pictures of top quality are all that is needed or wanted. Several large albumen prints can fill a room, as can one outsized contemporary piece. (In collecting daguerreotypes or other media in which size is generally smaller, a larger number of pieces is likely to accrue.) Collections of masterpieces can, however, look both highly impressive and somewhat empty, depending on how they are displayed. Shown as small groups of individual pieces they may lack a supporting context of their own. A more contextual approach, placing pieces more closely within the narrative of photographic history, can produce a more integrated impression, but the increase of breadth frequently occurs at the expense of the quality of individual pieces. (The exhibition related to Clarence White, discussed earlier, was criticized by reviewers in light of this criterion.) Both approaches can produce good results; success depends on melding the aims of the collector with the scope and impact he or she wishes to achieve.

KNOWLEDGE

With goals for a collection in mind, considerable study and background work still need to be done. For many collectors this is a central aspect of their collecting and involvement in the field: you would not, after all, be likely to want to collect something you didn't care about or understand. The regimen for this is the same as for learning anything else: study, discussion, and perusal of original materials.

Study, Discussion, Looking at Pictures

Study can take many forms. It does not always mean sitting down with a big book, although in the field of photography, a good deal has been published that is of use, and the books do tend to be large. Your own investigation could reveal leads to new work or inspire a trip to the locale in which a certain photographer worked in order to clarify some point of aesthetics or information. Reading or discussion might lead to more of the many ways knowledge relevant to photography can be encouraged or developed, such as visits to studios or archives. Frequently artists occupy a position as part of a larger matrix that can be explored; they are individuals with a history and philosophy. Where did these come from? a collector might ask. What do they mean in relation to the work? Artists are also part of families, regions, and schools: how did these influence them, or in turn affect their surroundings? If the artist is French, had he or she seen Russian work; if Italian, had he or she been to Paris, to New York? The answers to all of these questions provide information about the photographer and his work, and additionally point to new directions that might cause a collector to search out knowledge or opinion or redirect attention to new areas. The more familiar you are with the era, artist, or milieu that lies behind what you are collecting, the better prepared you will be to make the fine distinctions on which good collections are built.

Considerations like these are the grist of conversations among collectors or between collectors and curators, scholars, and art professionals. Discussions follow naturally from the study, travel, or perusal of original works. Collectors frequently compare notes on their search for work, their experiences at auctions, with dealers and galleries, their view of new information revealed in a recently published article or book. If there

is little or no overt photographic or art activity in your area,
you may find, or start, a group that focuses on photography or
related subjects: history, books, art. Colleges and schools,
museums and libraries, galleries and arts organizations are
places to look for such groups.

In seeking out knowledge of photographs, there is no sub-
stitute for seeing original work. The gamut of photography
runs from the family snapshots in the drawer of your dresser or
desk, or the photo in your passport, to rare and valuable items
seen most often behind the glass of museum displays. To grasp
the differences between different kinds of photographs, an
experience of images, artists, and media as varied as possible is
a key element. See as many displays in museums and galleries
as you can; it is also important to see and handle works
directly, as is possible at a dealer's or other location where
works are for sale, or at a museum print room, library, or his-
torical society. Again, the local or regional market is a good
place to begin. Almost any antique store will have pho-
tographs; see what they look like, what condition they are in,
how you respond to individual pieces. Collecting does involve
the choice of *particular* works; a larger context and knowledge-
able feeling for comparative elements in photography will help
in making these decisions.

Refinement and Change

While the direction of a collection is often established early on
as a goal, its delineation and boundaries are in need of constant
definition. The defining of direction is an ongoing activity. It
could involve, at different points, acquisition, deaccession, the
initiation of subcollections, or in extreme cases the sale of an
entire collection or a section of it in order to begin collecting in
a completely new direction. Such refinement or focus is the

product of expanded knowledge and taste, or perhaps merely a response to aspects of the market or to the activity of collecting itself. Few collections develop in a direct line; most encompass changes that have occurred along the way. Learning and change are positive aspects of collecting, not impediments that complicate it—although of course in a sense they do. In planning a collection the lessons of study and its allied activities are applied. Selections need to be made, categories of work expanded or reduced, the market responded to. In these ways a collection remains alive and responsive to the forces by which it was created, and in the end will better reflect the views and feelings of the collector.

Advice of Experts and Professionals

Often, collectors do not make acquisition decisions entirely on their own. First there are original sources to be consulted in shoring up specific knowledge about works, periods, and artists—articles, books, catalogs, and exhibitions. There are also the art professionals of photography—dealers, galleries, and auction houses—who provide information and advice. In addition there is a range of others, from photographers themselves to those who study and handle their work—curators, appraisers, writers, students, teachers, other collectors—each of whom is likely to have something useful to say.

In forming a collection, it is helpful to identify people in the field with whom to develop an ongoing relationship in which trust and understanding play a part. Over the course of assembling a collection, a collector might experience a series of trusting relationships: with a well-liked dealer or gallery owner, a curator who offers informed advice, a personal friend, advisor, or spouse who can share choices and decisions in an informal way. The strength of such relationships is that they can provide

some perspective within a framework of sympathy and understanding. The potential danger is conflict of interest or taste in forming the collection itself. Among those mentioned, roles and responses can be quite different. A dealer or gallery owner who is providing work of good quality may nonetheless have a personality, philosophy, or business practices at odds with yours. You might tolerate this, try to reach a common ground, or turn to another source. A curator or scholar may have his or her own intellectual or aesthetic ax to grind, lending a tone to the collection out of keeping with others. (Most professional curators and scholars will keep their distance from actual purchases, while freely offering opinions on topics of intellectual, artistic, or historical concern.) More ambitious collectors sometimes employ a curator of their own, a professional who serves as advisor, guide, and assistant on a consulting basis, freeing the collector from daily duties of care and research, and offering an informed sounding board for opinions. Whatever the specific relationship, few collectors work entirely on their own, and often count on such liaisons to supplement their own resources, experience, and time.

In short, forming a collection benefits from research and contact with original materials; from the resulting flexibility that allows comparisons and informed decisions; and from the advice of others in the field. An ideal balance between all of these may take some time to achieve, but keeping them in mind and working toward them will benefit the collector from the beginning.

COMMITMENT

The third element in an overall plan for collecting is to establish a level of commitment. Collections pass through a number of

stages and changes. Commitment generally grows with the confidence gained over a period in which collecting becomes more understandable, a habit, and even a part of one's way of life. While the beginning collector will probably at first be baffled by the profusion of sources, objects, media, and styles in photography, this will give way in the wake of experience to a calmer view in which categories begin to occupy their expected places in the larger field. This is certainly a stage you will pass through on the way from the commencement of a collection to its completion (a relative term, as collections seem never to be entirely completed). The commitment to reach collecting goals might thus be measured by recognizing these earlier stages of involvement and comprehension. Smaller steps enable larger ones; both are necessary if you are to proceed.

In a way similar to developing and monitoring personal commitment, the extent of the resources to devote to a collection needs to be established. Like a car, a home, or any other significant investment, collecting should reflect your priorities, needs, and means. Although it can be fun to explore and try something new, be sure the collecting you envision, and its related activities, fit your life and financial abilities. Collections are facilitated by planning and budgeting. How much time can you spend on building a collection? How much money are you willing to spend on works? Should collecting be a monthly, weekly, or daily activity? How will it relate to other commitments in your life—will it complement them or conflict with them? Such guidelines are best established at the outset. They can be changed and adjusted later. It would be unfortunate, however, to embark on a well-intentioned program of collecting only to find that adequate resources or time were not available. A useful device is to query others: How much time do they spend; how long did it take to build a collection; what did it cost? Such advice can be reassuring, or if discouraging at

least discovered in time to adjust course. In this regard, it is helpful to keep in mind a scale of values. Entire collections can be formed for the price of one highly valuable work. Seeing how other collectors have approached this equation of value will be helpful in developing your own.

Contact with other collectors can be useful in other ways. It is helpful in picturing the various modes of collecting and types of collections. In addition, the pleasures and obligations of collecting become clearer when seen in the context of individuals or groups who have made them part of their lives. For some, collecting is a personal activity centered on a home, weekend house, or other convenient location. For others it may be an activity related to work, perhaps as part of a corporate or business plan conducted in conjunction with office decoration and design, or with expansion or modification of a corporate or business image. While the styles of collecting may be somewhat different in each instance, the pleasures and obligations remain the same, though differing in degree. For many, the contact with original works is its own reward. Involvement with others who share a common interest, the exchange of experience and knowledge, and participation in the world of exhibitions, openings, publications, and the photography-related activities to which collecting is likely to provide entrée also provide satisfaction for the collector. In regard to the obligations of a collection, research and correspondence, the processing of loans for exhibitions, and contributions to the field itself—articles, exhibitions, or publications in which the collection can play a significant role—offer rewards that any collector will be proud to relate.

How the collector deals with these activities is a matter of personal or corporate style. In each case a level of commitment should be established that suits the needs and resources of those involved. At times determinations about goals can be

helpful in clarifying other issues: Are the goals to be enacted in collecting in line with others established by the family or business concerned?

An important subject in collecting related to commitment is the matter of investment. Photographs, like other art, have value, and although the appraisal of a collection is likely to increase over time, this is not inevitable. It has a great deal to do with the particular work selected and the uneven, somewhat unpredictable course of change in values and taste in the world of art. For most serious collectors, the commitment is to the works, and through them to the artists, periods, and schools they represent. If commitment to collecting is based on monetary value alone, it simply becomes another form of investment, subject to the familiar laws of supply and demand but also to currents of opinion and style that may be beyond the control of all but the most astute collector. Collecting to build value, rather than building value through an independent approach to collecting, is an activity akin to playing the stock market, with all the risks and satisfactions that accompany it. In the case of art, it is the feeling of many in the field that such activity is best pursued in other more appropriate spheres, leaving what would otherwise be ransomed art to those who genuinely care for it.

APPROACHES TO THE MARKET

With goals, knowledge, and commitment established, or well in view, it is time to deal with some of the key issues faced by any collector: what you might want versus what you can afford; the matter of value—what is a "good buy" and what is better left alone or for another time; the use of market niches attractive for their value versus the higher cost of a particular

era, artist, or style; making informed choices about rarity and quality. These matters constitute aspects of the practice of collecting. The market is the ultimate arbiter of availability and cost; appropriate responses take into account quality, value, and other factors over which the collector can exert control through individual decision. The results, and the response of others to the collecting you do, will depend on the standards and strategy you apply.

Adjusting what you want to what you can afford is of course a good idea. In reality, however, conflict appears with nearly every important picture encountered. It is almost unnatural not to be tempted by fine work. A firm sense of your resources tied to an overall plan or set of goals is the only genuine solution. In this light, the "good buy" could be quite the opposite. If the purchase of a photograph of moderate value keeps you from acquiring a better one, it is hard to say that progress has truly been served. In relation to a complete collection, the choice may be between acquiring an affordable body of work whose context is generally broad or to spend more money on a more focused era, artist, or style of concentrated value. This is a decision reflecting the goals, or possibly the temporary or interim goals, of the collector. It is likely to depend, in turn, on judgments of rarity and quality developed in the course of exposure to work, artists, or the market itself.

In all of these areas the market becomes the location where theories of collecting are played out. There are many reasons to collect photographs. Whatever approach you develop should reflect your particular interests, needs, and resources, and lead to a relation with collecting that is sustainable, comfortable, and secure. Many professionals and amateurs with a love of the field will help you get started. Get your feet wet and see how it feels!

8

CARING FOR A COLLECTION

As you begin to assemble a collection, the needs of the objects become a focus in themselves. While the many niceties of a well-cared for collection cannot be dealt with in great detail here, some guidelines can be offered for the beginning collector. Among the important topics are the basic protection and storage of works; proper methods of display; conservation of works; and matters of insurance and transport.

PROTECTION AND STORAGE OF WORKS

Probably the first necessity as you begin to assemble a collection of photographs is to develop a regular set of habits and routines through which the works acquired can be identified, sorted, accounted for, and stored. Such habits, leading to proper records and inventory, greatly simplify the complexities

of retrieving and handling the works themselves. At a later stage of collecting they will be invaluable for facilitating research as well.

As works are acquired, in collections both large and small, as complete a record as possible should be made of object, source, cost, condition, unique markings, and any other relevant information for each piece. This constitutes the basic catalog record of the work. Additional historical or other research can be added as necessary to the card, folder, or computer file holding the basic record. An indexed system, as is possible on spreadsheet software or by careful hand indexing, will make retrieval by subject, title, artist, school, or any other category for which a work is catalogued easier.

After cataloguing a work, it should routinely be placed in storage set aside for the purpose. The most common arrangement is a set of closed, acid-free, archival boxes stored horizontally on shelves. This provides a flexible and safe environment for the works as well as accessibility, aided by labels for identification. An alternative is a set of flat files, wide metal drawers, such as those used by architects and planners for the storage of blueprints. These are often more expensive, unavailable in small units, and difficult to move. The choice among such methods resides with the collector, but the objective is to house photographs in such a way that they lie flat and are exposed to as few physical hazards, such as sharp metal edges or irregular protrusions , as possible.

Within the storage boxes or drawers, photographs are kept separated by paper or large folders. Most desirable is to have each work separately matted. In all cases, archival materials should be used. The purpose of these measures is to protect the delicate surface of the picture from abrasion by sliding or rubbing against its neighboring works, to protect them from injury as they are handled, and to provide a chemically neutral envi-

ronment that discourages deterioration of the image. Storage papers, folders, and materials for matting are available from photographic supply houses. All materials should be of archival quality. Some dexterity is required to achieve good results in storage. If this is not your forte, it may well be worthwhile to consult a professional conservator of art who is conversant with the methods and materials necessary to high-quality storage.

A further important consideration is the condition of humidity, light, and heat in the storage area. Low light levels are always recommended for photographs, even when they are on display. Temperature should be under 65 degrees. Humidity should be as close as possible to 30%–50%. Photographs will last longer at lower temperatures, but the key consideration is the interaction of heat and humidity, and the desirability of a stable environment. A steady but less than perfect environment may be preferable to one extremely cool or dry from which pictures must be retrieved into normal heat and humidity for use.

Given a modicum of good practice in accessioning, cataloguing, and storage, a collector will still need to maintain and handle a collection on a daily basis. Oversight of works of photography includes regular examination for changes in temperature, humidity, or the intrusion of vermin that may feed on the paper and glue often used in matting. Pictures will also be removed for viewing or reproduction for record or publication. Handling should be done in the presence of the collector or a designated assistant. Cloth gloves are often worn to protect the surface of photographs from the natural oils of the hand.

Finally, though it is far from the mind of the collector, some thought needs to be given to the protection of valuable works in the event of disaster. If fire or flood should strike, or the roof begin to leak, how would these pieces, so carefully assembled, fare? Normal care should be taken to house a collection safely,

but thought devoted to the occasional extremity may eventually pay off. One California collector faced with housing his newly assembled works in a zone frequented by fire chose to put them in the basement; in the event of the unthinkable, he was prepared to leave his house, knowing that he would have to rebuild, but his collection of photographs would be safe.

METHODS OF DISPLAY

The archival matting used to protect pictures in storage will often serve adequately as their mode of presentation as well. In either case, whether for storage or display, these acid-free mats should be cut principally to provide protection to the work of art and to augment its appearance in as simple a manner as possible. Frames are an additional protection, cushioning the work if it should fall, holding a sheet of Plexiglas or glass to protect the surface of the print, and further protecting the mat holding the photograph.

Proper display of photographs involves the same conditions as those for storage: temperature, light, and humidity. More light is of course involved in display than in storage, and today it is usually recommended to use a Plexiglas resistant to ultraviolet rays in the framing of photographs. Although photographs should never be hung in direct light, protection from ultraviolet rays, even in shade, is still an important factor in preserving the freshness of the original image.

MATTERS OF CONSERVATION

Physical problems with photographs should be dealt with by a professional conservator. Matters ranging from surface dirt to

Proper matting of a photograph or print.
Print is mounted on firm
archival backing with
paper and glue or
linen tape; hinged
window mat is cut
to reveal print.

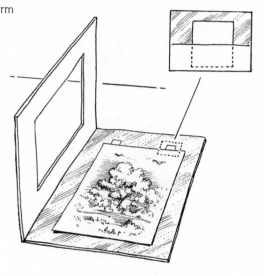

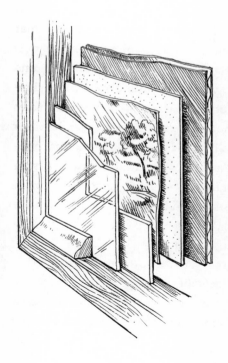

Elements of framing.
Left to right: Frame,
molding, glass cover,
mat, print, back of mat,
backing for frame.

minor scratches and tears can be treated relatively inexpensively. Major damage, however, can be costly. Conservators will frequently offer a brief assessment of the problem without cost. This is a good way to ascertain whether or not a repair is feasible and affordable. Treatment of works is highly specialized and demanding. In looking for a good conservator, note the conditions under which he or she works. Cleanliness, order, space, and appropriate tools are good signs. A recommendation from a satisfied client, in person if possible, can be extremely useful. Conservators of photography are relatively rare. Contacting a regional conservation lab or the photography department of a major museum is a good way to track down a professional in the field.

TRANSPORT AND INSURANCE

There are many circumstances, such as the loan of work to exhibitions, and inspection and return of prospective purchases, under which photographs need to be packed and shipped. While, like other prints, they are conveniently light and flat, they are also delicate. Care must be taken to pack them firmly in order that they not slide against each other, bend, or fold in shipping, or their edges curl against the interior of the packaging. In the case of framed work, additional care must be taken to protect the photograph's Plexiglas cover. Well-packed photographs, properly marked and handled, can be carried by hand, shipped, or even mailed. As with conservation, packing should be left to an experienced hand.

Photographs, like any other artwork, should be insured to the extent that the owner feels they can be replaced, or substitutes found, in the case of damage or loss. Collections housed at home, in an office, or some other already insured location

may often be covered in a rider on an existing policy. Similarly, loans of pieces to museums or galleries for exhibitions are usually covered by those institutions as extensions of their own policies. In the case of travel or mail between collectors, collectors and dealers, collectors and scholars, and other such cases, varying kinds of insurance exist. It is certainly wiser to insure a collection and its contents; nothing, however, will replace care taken in storage, packing, choice of carrier, and full knowledge of the destination to which they will be transported.

SUGGESTED REFERENCES

Of the several books available about collection care, two that may prove useful are the very thorough *The Life of the Photograph*, by Lawrence Keefe and Dennis Inch, and James M. Reilly's *Care and Identification of 19th-Century Photographic Prints*. The latter contains an especially good chart for identifying the various photographic processes in common use including several well into the twentieth century.

Materials can be obtained through photographic and archival supply houses in many cities. A number of these have mail order catalogues and in some cases online services. Three that handle photographic materials are Light Impressions of Rochester, and Gaylord Brothers of Syracuse, both in New York State; University Products, Inc., is in Holyoke, Massachusetts. Similar services are available in many major cities.

9

RESOURCES AND TOOLS

EXHIBITIONS

One of the great pleasures of collecting is the opportunity—the necessity—of remaining familiar with ongoing exhibitions. Exhibitions display the research and thinking of curators and scholars and routinely bring to the attention of collectors and the public the work of a wide variety of photographers, eras, and schools. In the forefront of the recent movement toward ambitious exhibitions are the large urban museums. In New York, shows mounted by the Museum of Modern Art, and more recently the Metropolitan Museum of Art and the International Center of Photography, have set a pace that lesser institutions find difficult to match. In Washington, the National Gallery of Art is only one of several institutions with regular exhibitions of photography. Museums in Baltimore, Houston, Chicago, San Diego, Los Angeles, and San Francisco are all well

known for their programs in the field. In Canada, the National Gallery in Ottawa has an outstanding record of exhibitions, as does the Candian Centre for Architecture in Montreal. Great photography can frequently be seen in London, Paris, and other cultural centers.

Closer to home, for many, are the smaller museums, libraries, historical societies, and galleries that often display the work of individual artists or specific periods, frequently borrowing works or exchanging exhibitions in order to expand the scope of their more modest permanent collections. Such exhibitions provide a range of new work that can set a collector thinking, and searching. Even in the larger cities many such venues exist for exhibitions of photography: the New York Public Library, the California Historical Society in San Francisco, and the Center for Creative Photography in Tucson, as well as many college and university galleries in cities large and small, are frequent hosts to exhibitions of photography. Corporations often include photography, especially contemporary works, among their collections of art; some, like Seagram's in New York, offer a public gallery in their headquarters. Listings for such shows can be found in periodicals, cultural calendars, and art publications available in libraries, retail stores, or through subscription by mail.

COLLECTIONS

In general, great collections are held by great institutions. New York, Washington, Paris, and London hold collections of long standing whose depth and breadth are impossible to duplicate today. Many other collections, more recent and frequently more focused, are held by institutions and in locations not as well known. According to your interest, you can learn a lot about

photography by consulting collections in libraries, corpora-tions, and archives, as well as those held by galleries, dealers, private collectors and clubs. Much good photography is found in albums not frequently displayed or among the oeuvres of artists held in private by families and estates. Such collections require some detective work on the part of the aspiring collec-tor; good instinct combined with good luck are often the key.

Programs, Organizations, Groups

A number of groups interested in photography offer informa-tive programs to beginning collectors, as well some more advanced. Introductory courses and seminars are offered by colleges, libraries, and schools. Groups such as San Francisco's Friends of Photography offer collector print programs that introduce collectors to new artists and work or to limited edi-tions otherwise unavailable. Meetings and symposia are pre-sented by professional organizations, museums, and galleries. Membership groups, such as AIPAD, an association of photog-raphy dealers, bring together large presentations of work in conjunction with public programs on collecting, and on pho-tography itself, to offer a new marketplace and an educational opportunity to collectors and amateurs alike. These groups and organizations can be reached through galleries, dealers, or members.

Books, Publications, Catalogs

The resurgence of photography as an art has spawned an increasingly large crop of publications—both books and peri-odicals. Only a brief sampling can be listed here.

General Histories

Gernsheim, Helmut and Alison. *History of Photography.* McGraw-Hill, New York, 1969, and subsequent editions.

Newhall, Beaumont. *History of Photography.* Museum of Modern Art, New York, 1937, and subsequent editions.

Rosenblum, Naomi. *A World History of Photography.* Abbeville Press, New York, 1984.

Szarkowski, John. *Photography Until Now.* Museum of Modern Art, New York, 1989.

Travis, David, et al. *On the Art of Fixing a Shadow.* National Gallery of Art/The Art Institute of Chicago, Washington/Chicago, 1989.

Specific Eras and Schools

Brettell, Richard, et al. *Paper and Light: The Calotype in France and Great Britain, 1839–1870.* David R. Godine, Boston, 1984.

Bunnell, Peter, ed. *A Photographic Vision: Pictorial Photography, 1889–1925.* Peregrine Smith, Salt Lake City, 1980.

Fabian, Ranier, and Adam, Hans-Christian. *Masters of Early Travel Photography.* Vendome Press, Paris, 1981, New York, 1983.

Foresta, Merry, and Wood, John. *Secrets of the Dark Chamber: The Art of the American Daguerreotype.* National Museum of American Art, Washington, 1995.

Frank, Robert. *The Americans.* (1959). Revised edition, Aperture, Millerton, N.Y., 1978.

Gardner, Alexander. *Photographic Sketchbook of the Civil War,* (reprint). Dover Publications, New York, 1959.

Green, Jonathan. *Camera Work: A Critical Anthology.* Aperture, Millerton, N.Y., 1973.

Grundberg, Andy, and Gauss, Kathleen M. *Photography and Art: Interactions Since 1946.* Abbeville, New York, 1987.

Hall-Duncan, Nancy. *The History of Fashion Photography.* Chanticleer Press, New York, 1977.

Haworth-Booth, Mark, et al. *The Golden Age of British Photography.* Aperture, Millerton, N.Y., 1984.

Homer, William Innes. *Alfred Stieglitz and the Photo-Secession.* Little, Brown, Boston, 1983.

Jammes, Andre, and Janis, Eugenia. *The Art of the French Calotype.* Princeton University Press, Princeton, 1983.

Jenkins, William. *New Topographics.* George Eastman House, Rochester, 1975.

Lewinski, Jorge. *The Camera at War.* Simon and Schuster, New York, 1978.

Naef, Weston. *The Collection of Alfred Stieglitz: Fifty Pioneers of Modern Photography.* Metropolitan Museum of Art and Viking Press, New York, 1978.

Naef, Weston, and Wood, John. *Era of Exploration.* Albright-Knox/Museum of Art, Buffalo and New York, 1975.

Newhall, Nancy. *P. H. Emerson: The Fight for Photography as a Fine Art.* Aperture, Millerton, N.Y., 1975.

Rudisill, Richard. *Mirror Image.* University of New Mexico Press, Albuquerque, 1971.

Sobieszek, Robert. *The Art of Persuasion: A History of Advertising Photography.* Harry N. Abrams, New York, 1988.

Steichen, Edward. *The Family of Man.* Museum of Modern Art, New York, 1955.

Stott, William. *Documentary Expression and Thirties America.* Oxford University Press, New York, 1973.

Sontag, Susan. *On Photography.* Farrar, Straus, & Giroux, New York, 1977.

Wallis, Brian, ed. *Rethinking Representation.* David R. Godine, Boston, 1984.

Wood, John. *The Art of the Autochrome.* University of Iowa Press, Iowa City, 1993.

Collecting

Bennett, Stuart. *How to Buy Photographs*. Phaidon Press, Oxford, 1987.

Jacobson, Marjory. *Art for Work: The New Renaissance in Corporate Collecting*. Harvard Business School Press, Boston, 1993.

Mace, O. Henry. *Collector's Guide to Early Photographs*. Wallace-Homestead, Radnor, Pa., 1990.

Witkin, Lee D., and London, Barbara. *The Photograph Collector's Guide*. New York Graphic Society, Boston, 1979.

Periodicals

Of the many publications devoted to photography, several are especially useful in following the development of new directions in scholarship and critical thought. Among them: *History of Photography, October, Afterimage,* and more recently, *On Paper* and *Blind Spot*. Others, such as the more popular *American Photo,* focus more on the working photographer but have featured articles on collecting and subjects relevant to it. *The Photograph Collector* and its related *Photo Review Newsletter* are good sources of information for collectors as well. There are many other sporadic or short-lived productions. Major publications, such as the *New York Times* as well as broader-based magazines centered on art, history, and antiques, frequently address current exhibitions or publications in the field of photography. A good current national and international listing of photography-related events, including exhibitions, seminars, auctions, and listings of dealers and their addresses, can be found in the semi-monthly *Photography in New York.*

Most of these publications are available or can be ordered at major libraries or newsdealers. Also available at libraries that specialize in, or include a focus on the arts are auction catalogs and price guides, which come out on a regularly scheduled

basis and are useful in tracking prices and availability of works currently on the market. Some periodicals and organizations are also accessible online.

Conservation and Care

As general introductions to the care of photographs, *The Life of a Photograph,* by Lawrence Keefe and Dennis Inch (Focal Press, Boston and London, 1983) is complete and thorough. James Reilly's *Care and Identification of 19th-Century Photographs,* published by Kodak in 1986, focuses on that specific era and provides a bibliography on issues of archiving and conservation. *The Keepers of Light* by William Crawford (Morgan and Morgan, Dobbs Ferry, N.Y., 1979) answers many technical questions, especially about the difficult Pictorialist era. Gordon Baldwin's *Looking at Photographs* (Getty Museum, Malibu, with the British Museum Press, 1991) is an excellent, brief illustrated guide to the terms and concepts necessary to understand and talk about photography. The *Encyclopedia of Photography,* published by the International Center of Photography in 1984, is a complete source book for questions of a technical nature. For equipment and materials a good first stop is Light Impressions of Rochester, New York.

~

Glossary

Albumen print: A print made on paper prepared from the albumen of eggs. Often a rich brown; the most common print of the nineteenth century.

Ambrotype: A collodion negative print on glass, often small. Similar to a daguerreotype, but usually less clear and never metallic.

Archival materials: Chemically neutral papers, glues, and other materials that help to prolong the life of a photograph.

Autochrome: An early color process on glass, most popular in the years surrounding the turn of the century.

Calotype: A print on paper, usually a salt print, from a paper negative, made by the process developed by photographic pioneer W. H. Fox Talbot, and patented in 1841.

Camera: Found in many forms, the camera is the light-sealed box in which a photographic film or plate can be safely exposed. Early cameras were made of wood; today they take a variety of forms, usually of metal, or more recently plastic.

Camera lucida: A nineteenth-century invention which, through the use of a prism mounted by a rod to a drafting board, aided an artist or draftsman by providing the illusion that the image viewed through the prism was in fact appearing on the drawing board.

Camera obscura: A portable box or room, darkened within, which by means of a tiny hole (sometimes with the aid of a lens) in one wall causes an image from outside to be projected on the opposite inside wall. An aid to drawing and precursor to the camera.

Carte-de-visite: A small albumen print, typically $4\frac{1}{2}$ by $2\frac{1}{2}$ inches, mounted on a cardboard card. Most frequently used as an inexpensive form of portraiture. The cabinet card, of about 4 by 6 inches, was a slightly larger version of this style of presentation, and was more frequently used for other subjects, including landscape.

Chromogenic print: A color print based on the use of three separate layers of photosensitive material, each recording one of the primary colors, blue, red, and green. In combination, the print's three layers encompass the entire spectrum of color.

Collage: The use of photographs in multimedia works, for which they may have been cut, pasted, lettered, or otherwise adapted. Collages are sometimes the basis for a final rephotographed work.

Collodion: A sticky substance used for coating glass plate negatives; the basis of the wet plate process.

Combination print: A single print produced from more than one negative.

Contact print: A print, most often of the nineteenth century, made by laying the negative directly over the paper on which the print is to be made. The resulting print is thus exactly the same size as the negative.

Cropping: The process of changing the appearance of a print by altering its borders, either by cutting the actual print or by cutting or masking out portions of the negative to achieve an image of different proportions.

Cyanotype: A process developed early in the history of photography, and still used, based on the light-sensitive properties of iron salts. Cyanotypes are distinctive for their bright blue (cyan) color.

Daguerreotype: A photograph produced by the process perfected by L. J. M. Daguerre, announced to the public in 1839, of recording and fixing photographically on a silvered metal plate, the image produced by a camera.

Developing: The process of bringing out an image latent in a potential negative or print through immersion in a chemical bath.

Digital photography: Photographs produced, reproduced, stored, and potentially altered by electronic means. Images can be viewed electronically on a television screen or computer monitor, or printed out in any of a variety of media.

Documentary: The use of photography to record, in as objective a manner as possible, events, social conditions, and a wide variety of other subjects.

Dodging: A method of lightening dark areas of a print by blocking selected areas of the image during enlargement.

Dry plate: A later, commercial adaptation of the wet plate process that allowed photographers to purchase glass plates suitable for negatives already prepared and ready for use.

Dye processes: These complex, modern color processes produce prints through the use of color separation and the combining of primary colors to reproduce the entire spectrum.

Enlarging: The process, quite common today, of making a print larger than its negative by projecting the lighted image of the negative onto printing paper (or other support) through an enlarging lens.

Gelatin: The most common substance used as a base for photosensitive materials, especially printing papers. First introduced in the 1870s.

Gravure: A method of printing photographs in ink from a metal plate.

Hologram: A three-dimensional photograph produced through the use of lasers.

Hypo: A bath of sodium thiosulfate, originally sodium hyposulfite, which through immersion fixes the photographic image, preventing it from further development.

Latent image: Image recorded on a negative or print, but brought out only by further processing.

Negative: The original recorded camera image, with reversed light values, from which a positive print, with correct values, is printed.

Photogenic drawing: The earliest known photographic works of W. H. Fox Talbot, the British inventor of photography on paper. A cameraless process that produced a negative image with dark and light values reversed. The most common subjects are plant forms and lace.

Photogram: A cameraless photograph made by exposing photographic paper, with objects placed directly on it, to light. Popular especially among early modernists.

Photomechanical processes: Methods of reproducing photographic images in quantity from a plate created directly from an original negative or print. Processes include photolithography, collotype, photogravure, and the Woodburytype.

Pictorialism: Most commonly, the period from the 1880s through the 1920s during which photography was pursued as a fine art, and photographs produced with purely aesthetic intent.

Pigment prints: Photographs produced using inks and other pigments, rather than the typical silver-based image. The pigment processes frequently encountered include carbon, bromoil, carbro, and gum bichromate.

Plate: A term used variously to describe, among others, the glass used for a photographic negative, the metal support of a daguerreotype, the metal sheet from which a gravure is made, and printed photographic illustrations themselves. As a measurement, the "full" plate of the daguerreotype measured typically $6\frac{1}{2}$ by $8\frac{1}{2}$ inches; fractional plates could be obtained from half that size down to a ninth or sixteenth. In reference to glass plates, the typical full plate was 8 by 10 inches, with smaller fractions available, as well as the rarer larger plates such as the "mammoth" plate, often 18 by 22 inches or larger.

Platinum/palladium print: A printing process using these precious metals rather than silver as the medium for the image.

Retouching: Hand repair or alteration of a photographic image; frequently used in portraiture; sometimes done with light color or paint for accentuation.

Salt print: An early form of positive print, c. 1850–1860, usually a contact print on paper sensitized in a sodium chloride (salt) solution, then coated with silver nitrate. Most often used with negatives of paper or glass.

Solarization: A darkroom method that produces a unique effect of reversal of tone and a resulting outlining of form, especially popular among modernists early in the twentieth century.

Spotting: The practice of repairing the minor imperfections of a final print, often with a fine brush; a specialized and less intrusive form of retouching.

Stereograph: Paired set of photographs, often albumen prints, taken and mounted so as to be viewed together through a stereoscope, giving the illusion of depth.

Tinting: The introduction of mild color to an entire print through the introduction of specialized chemicals to its materials.

Tintype: Direct photographic print on shellac-coated metal. An inexpensive form of photograph often used for portraits and keepsakes.

Toning: Chemical treatment to adjust the tone, contrast, and stability of a print. Many different toning processes exist.

Topographic: A term denoting a wide variety of photographic subjects relating to landscape, settlement, exploration, and travel.

Vignetting: The practice, often reaching the level of a convention, of presenting an image in a stylized form such as an oval, regardless of its original, usually rectangular, form.

Vintage print: A print made close to the time its original negative was exposed, usually by the artist, but alternately by an approved and designated printer.

Waxed paper process: An improvement on the calotype process, making the paper negative more translucent and capable of recording nuance and detail. Introduced by Gustave Le Gray in 1851.

Wet plate: A common nineteenth-century process by which a negative on glass is produced through use of a photo-sensitive emulsion that must be exposed and developed while still moist.

Index